Delhi Ontario and Area in Colour Photos, Saving Our History One Photo at a Time

Photography
by Barbara Raué
2015

Series Name:
Cruising Ontario

Book 112: Delhi and Area

Cover photo: Lynnville, Page 53

Series Name: Cruising Ontario
Saving Our History One Photo at a Time
in colour photos

Books Available in Alphabetical Order:
Aberfoyle, Acton, Alton, Ancaster, Arthur, Aylmer, Ayr, Bloomingdale, Brantford, Burlington, Caledon, Caledonia, Cambridge, Clifford, Conestogo, Delhi, Dorchester to Aylmer, Drayton, Drumbo, Dundas, Eden Mills, Elmira, Elora, Fergus, Guelph, Hagersville, Hamilton, Hanover, Harriston, Hespeler, Jarvis, Kitchener, Linwood, Listowel, London, Lucknow, Mono, Mount Forest, Neustadt, New Hamburg, Niagara-on-the-Lake, Oakville, Orangeville, Orillia, Owen Sound, Palmerston, Peterborough, Port Elgin, Preston, Rockwood, Seaforth, Sheffield, Shelburne, Simcoe, Southampton, St. Jacobs, St. Thomas, Stoney Creek, Stratford, Tillsonburg, Waterdown, Waterford, Waterloo, Wellesley, Wingham

Book 110:Lucknow, Mitchell
Book 111: Conestogo, Bloomingdale
Book 112: Delhi
Book 113: Waterford
Book 114-116: Waterloo

Other Books by Barbara Raue

Coins of Gold

Arrows, Indians and Love

The Life and Times of Barbara
Volume 1: Inventions That Have Enhanced My Life
Volume 2: Entertainment That I Have Enjoyed
Volume 3: East Coast Trips
Volume 4: Olympics Have Always Intrigued Me
Volume 5: Wonders of the World
Volume 6: Caribbean Cruises We Have Enjoyed
Volume 7: Animals
Volume 8: Storms and Other Major Disasters in My Lifetime
Volume 9: Wars, Terrorist Attacks and Major Disasters

The Cromwell Family Book

Laura Secord Discovered

Daddy Where Are You?

Visit Barbara's website to view all of her books
http://barbararaue.ca

Table of Contents

Delhi	Page 7
Port Ryerse	Page 30
Fishers Glen	Page 35
Normandale	Page 36
Turkey Point	Page 41
LaSalette	Page 42
Windham Centre	Page 45
Lynnville	Page 49
Concession 4	Page 53
Simcoe (a few pictures)	Page 56
Curries	Page 58
Springford	Page 60
Architectural Terms	Page 63
Building Styles	Page 67

Norfolk County is a rural municipality on the north shore of Lake Erie in Southwestern Ontario. The county seat and largest community is Simcoe. Some of the most notable communities in Norfolk County are Delhi, Port Dover, Simcoe, and Waterford.

Surrounding its many small communities is some of the most fertile land in Ontario. With a mild climate and lengthy growing season, the region has long been the centre of the Ontario tobacco belt. Many farmers have begun the process of diversifying their crop selections to include lavender, ginseng, hazelnuts, and wolfberries as tobacco consumption continues to decrease.

Delhi

Delhi is located off the junction of Highways 53 and 3. Founded by Frederick Sovereign as Sovereign's Corners around 1826, the community was renamed Fredericksburg and eventually its present-day name of Delhi, the name usually attributed locally to a postmaster honoring a major city of the British Empire, Delhi, India. Prior to 1880, this town was known for its lumber industry.

Port Ryerse

Port Ryerse is a fishing hamlet in Norfolk County southwest of Port Dover where people rent cottages and fish for pleasure during the summer months.

Lieutenant-Colonel Samuel Ryerse (1752-1812), a United Empire Loyalist, was commissioned in the 4th New Jersey Volunteers during the American Revolution following which he took refuge in New Brunswick. In 1794 he came to Upper Canada, and the following year received 3,000 acres of land in Woodhouse and Charlotteville townships. Settling at the mouth of Young's Creek, he erected a grist mill around which grew Port Ryerse.

William Pope (1811-1902) grew up in the lush countryside of England and studied painting at the Academy of Art, London. Reports of abundant wildlife drew the sportsman and naturalist to Upper Canada in 1834. After three extended visits, he settled permanently with his family near Port Ryerse in 1859. Financially independent, Pope spent his days hunting, sketching and painting the local flora and fauna. His watercolors of birds are compared to those of John James Audubon. Along with his paintings, Pope's diaries and journals provide a detailed record of the wildlife once plentiful in this region. Most of his works are now in the Metropolitan Toronto Reference Library.

Fishers Glen

Fishers Glen in Norfolk County, is a fishing community located south of Simcoe and southwest of Port Ryerse. It is famous among locals for being one of the best fishing spots in Lake Erie during the summer months.

Normandale

Normandale is a quaint fishing town in southwestern Norfolk County that is famous for its perch and black bass. Agriculture plays a small role here.

Turkey Point

Turkey Point is a village in Norfolk County located on Long Point Bay south of Highway 24 on Regional Road 10, southwest of Simcoe.

La Salette, Lynnville and Windham Centre are in Norfolk County.

The Township of Norwich is located in Oxford County in southwestern Ontario. The origin of Norwich, Ontario, is likely Norwich in Upper New York State, where the pioneering families emigrated in the early 19th century. Oxford County Road 59 is the major north-south highway through much of the township. The local economy is largely agricultural, based on corn, soybean, and wheat production with dairy farming in the north part of the township and tobacco, vegetable, and ginseng farming to the south. Slowly, ginseng and traditional cash crops are replacing the former cash crop - tobacco, as demand shrinks.

Norwich Township includes the communities of Curries, Eastwood, Norwich, and Springford.

Delhi

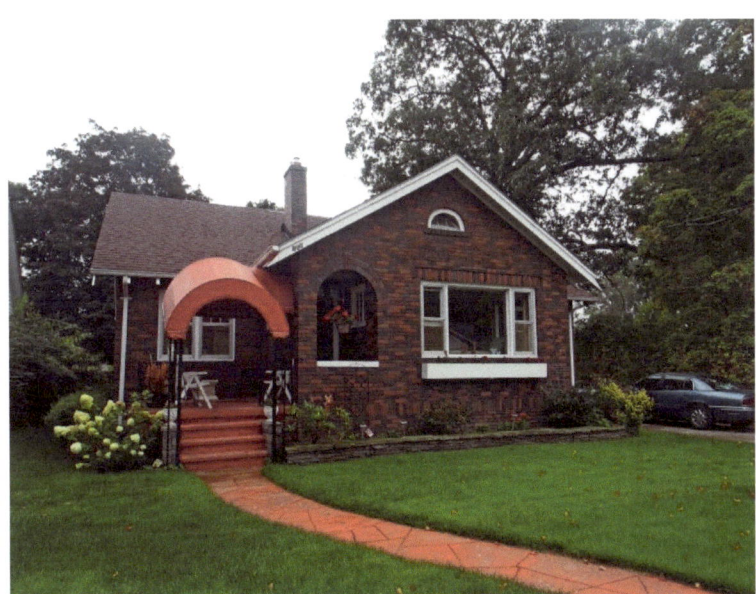

#166 - impressive red walkway, and red carpeting on steps

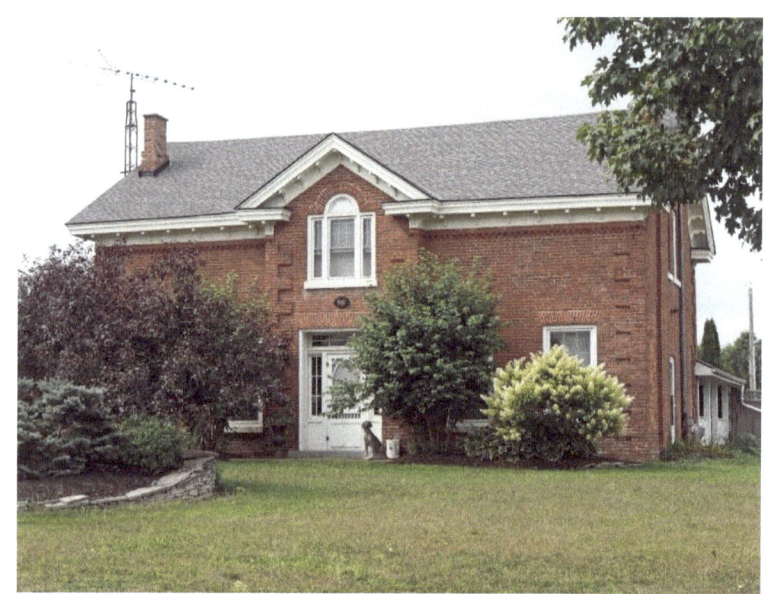

#802 – Gothic Revival, corner quoins, Palladian window

Gothic Revival

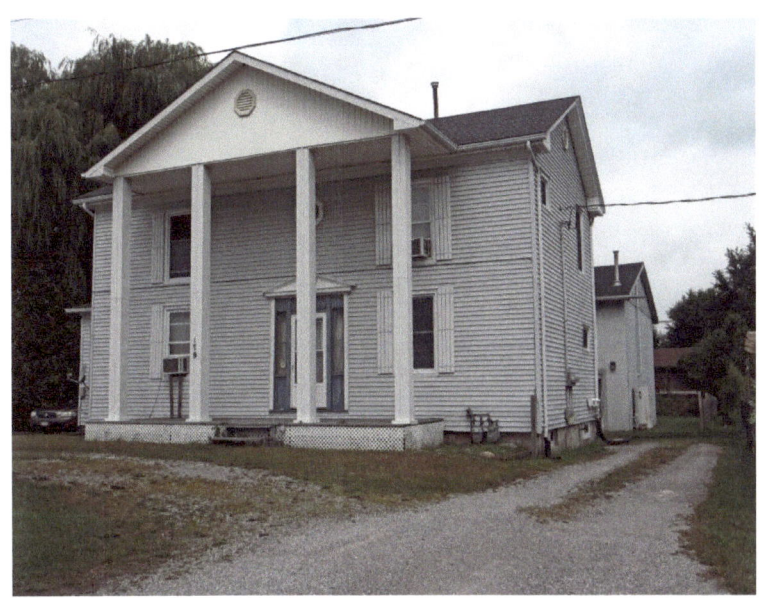

Classical Greek

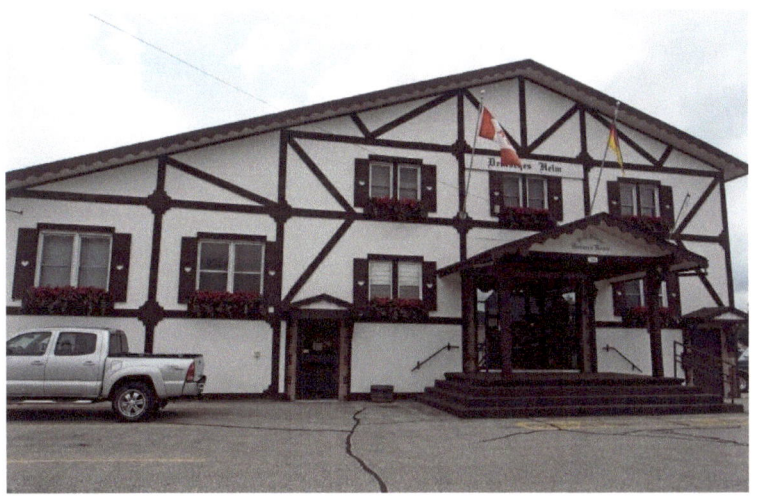

#443 - Delhi District German Home - Tudor accents

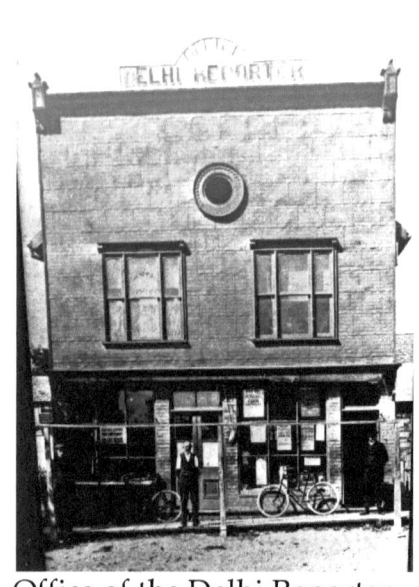
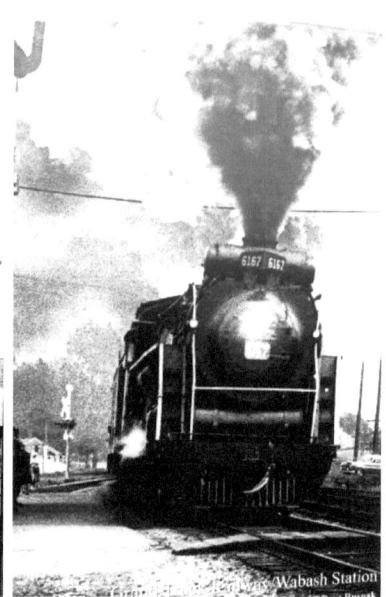

Office of the Delhi Reporter Wabash Station

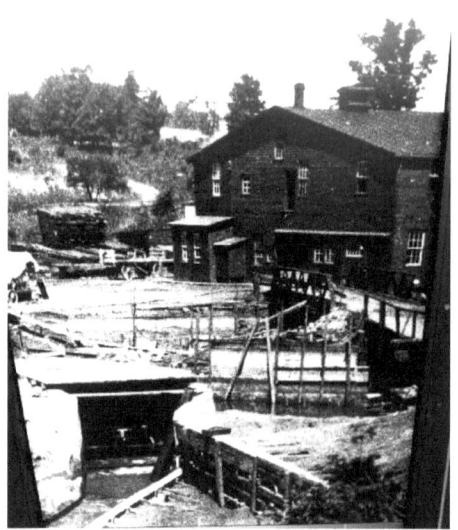

Quance Mill

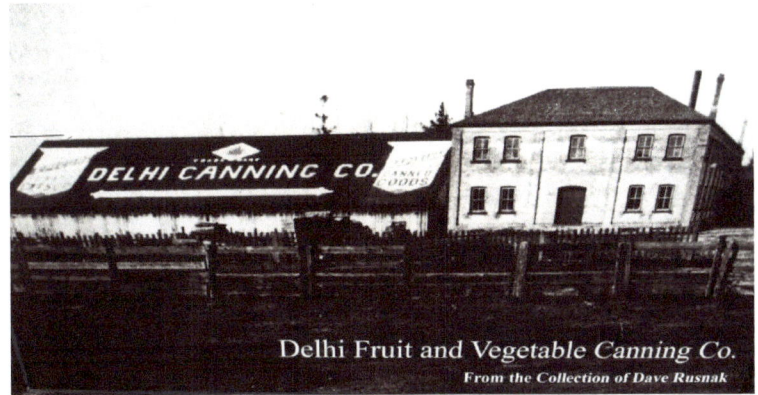

Delhi Fruit and Vegetable Canning Company

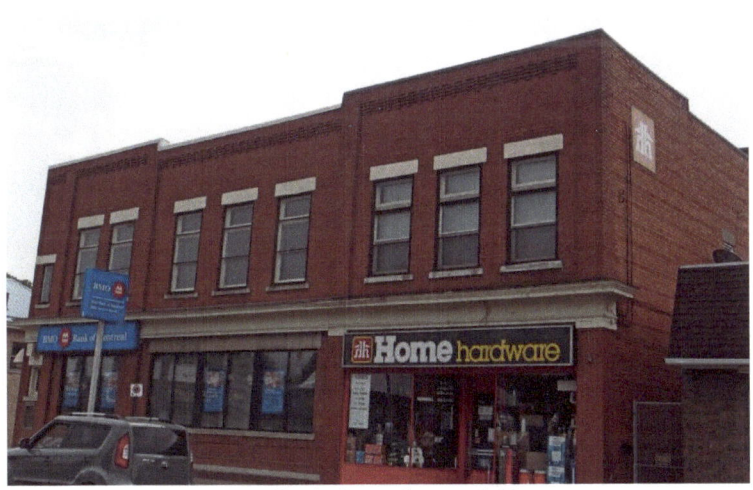

Bevelled dentil moulding

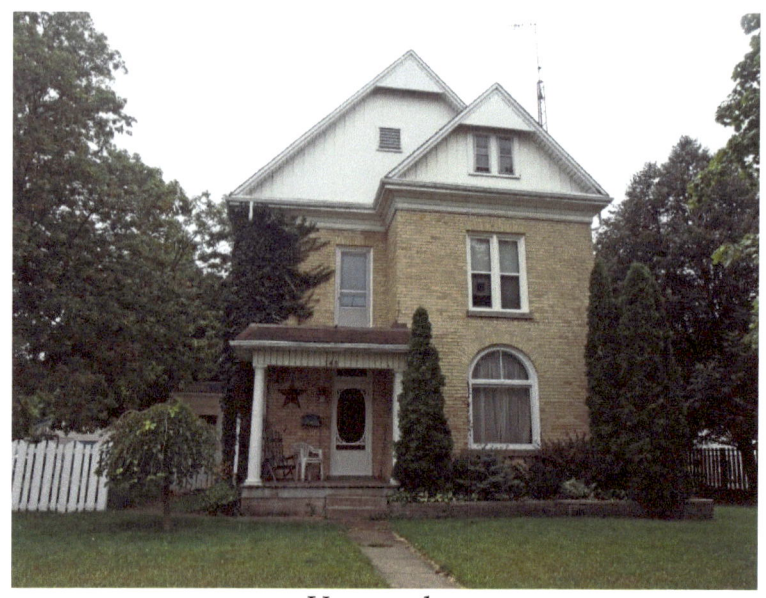

Vernacular

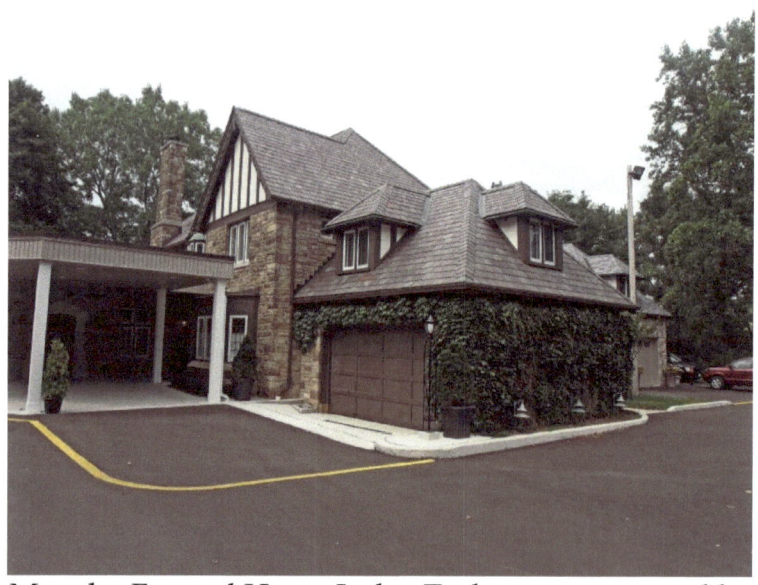

Murphy Funeral Home Ltd. – Tudor accents on gable, dormers above garage

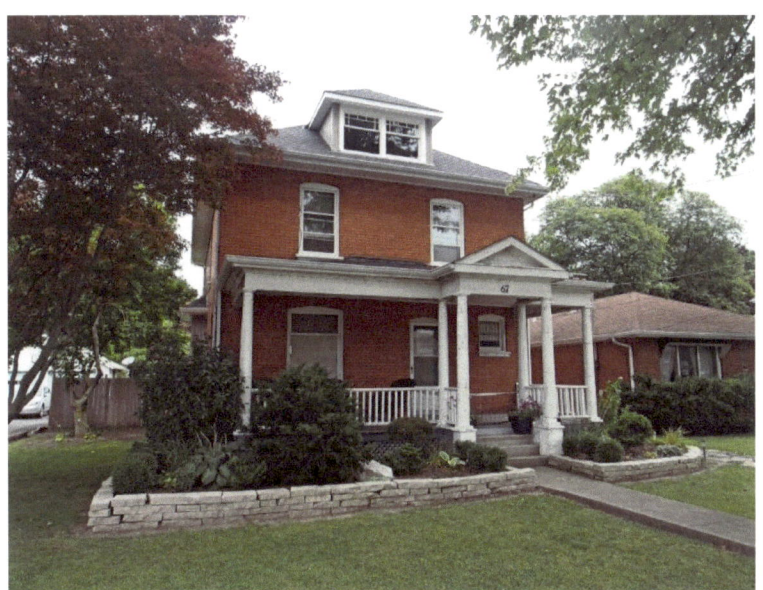

Italianate, pediment, dormer

Hipped roof

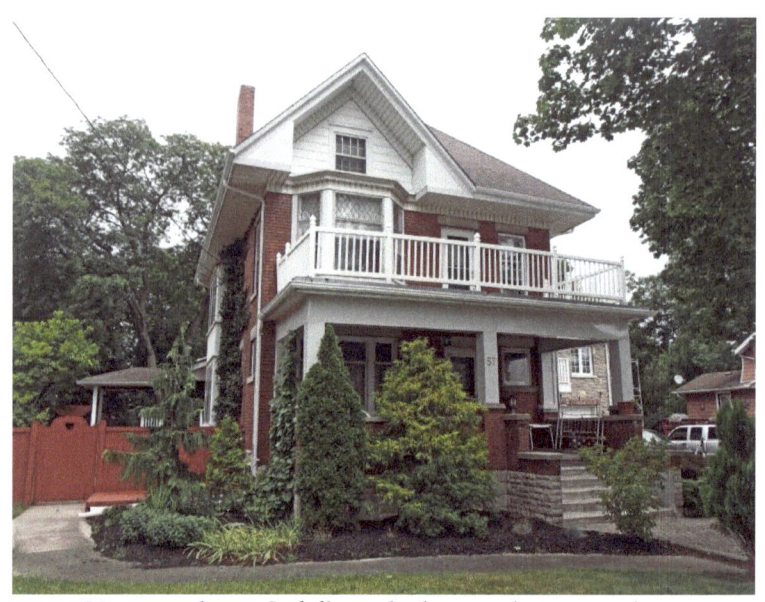

Vernacular – 2nd floor balcony, bay window

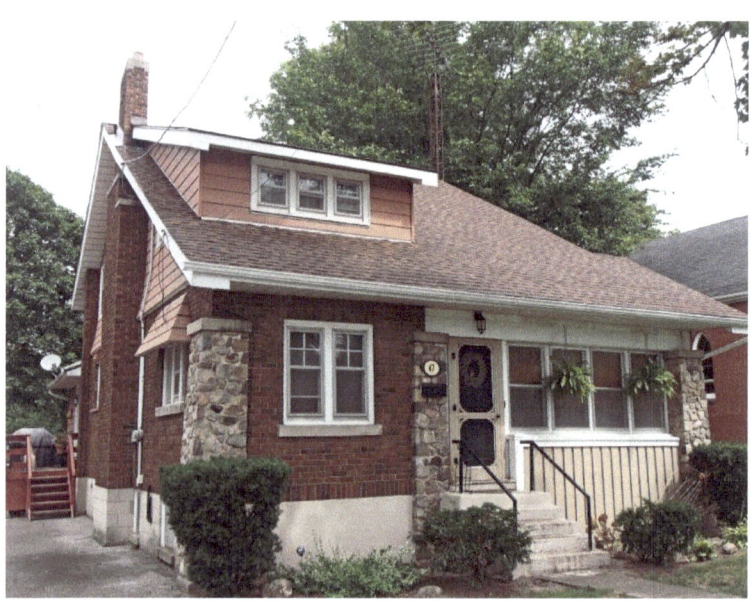

Dormer

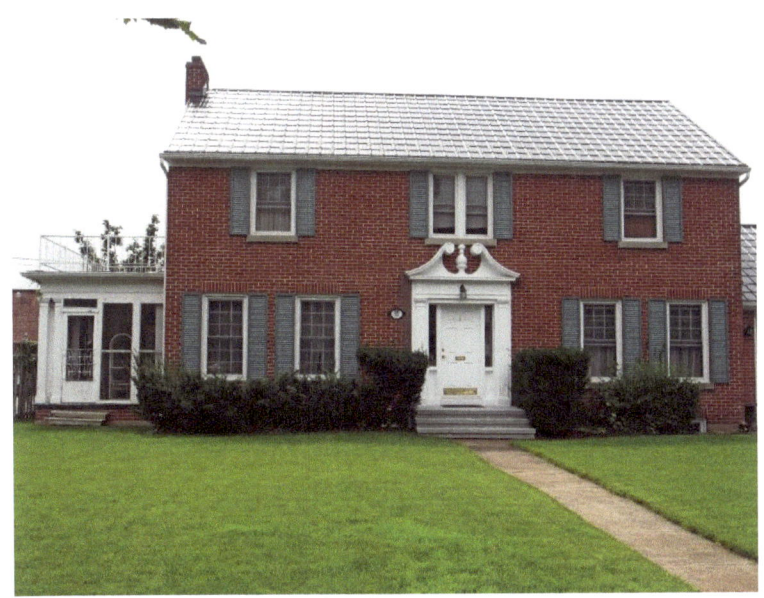

#52 - Georgian

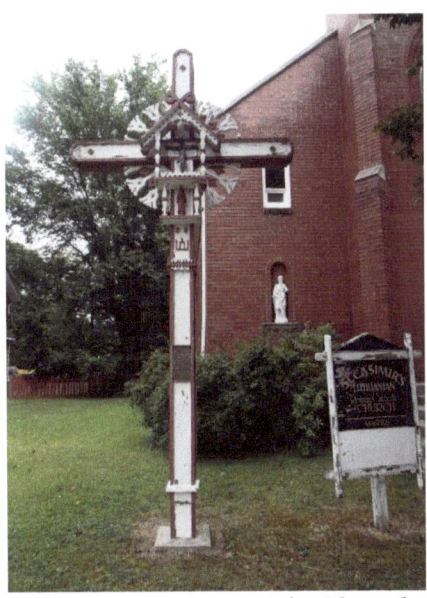

Cross at St. Casimir's Church

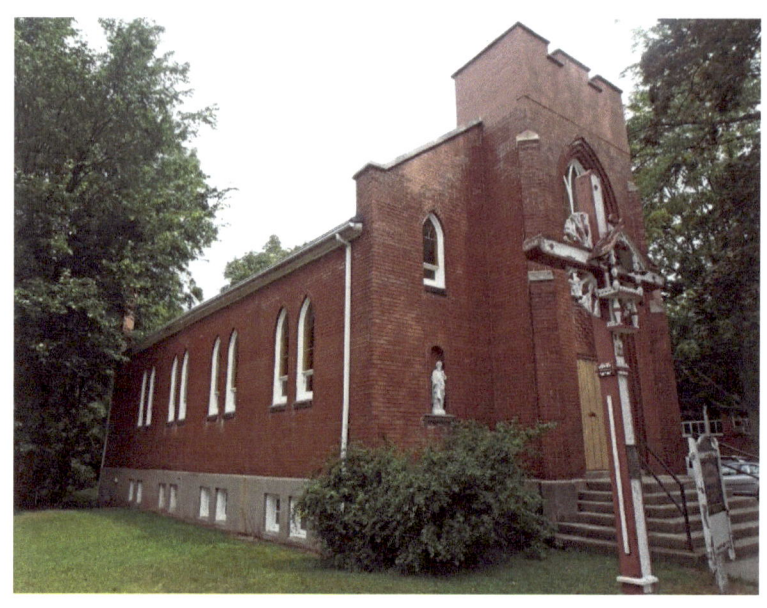

St. Casimir's Lithuanian Roman Catholic Church
January 1933 – lancet windows, crenelated tower

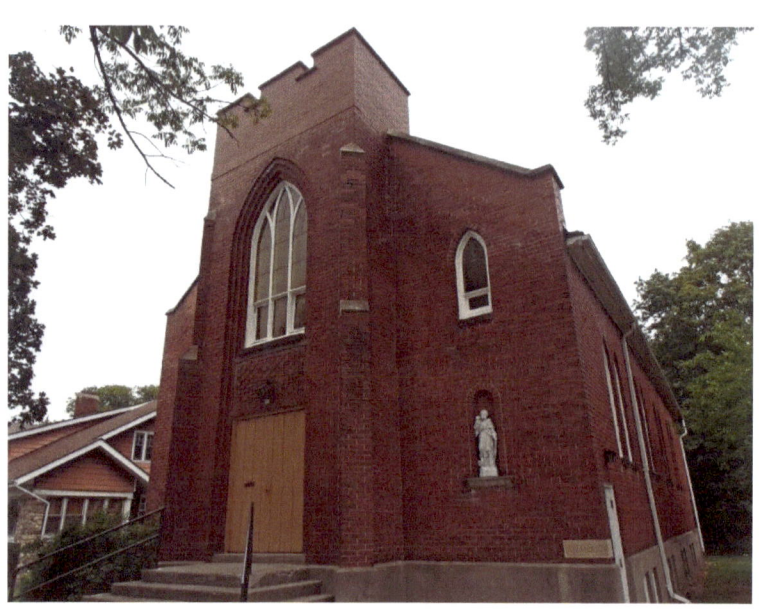

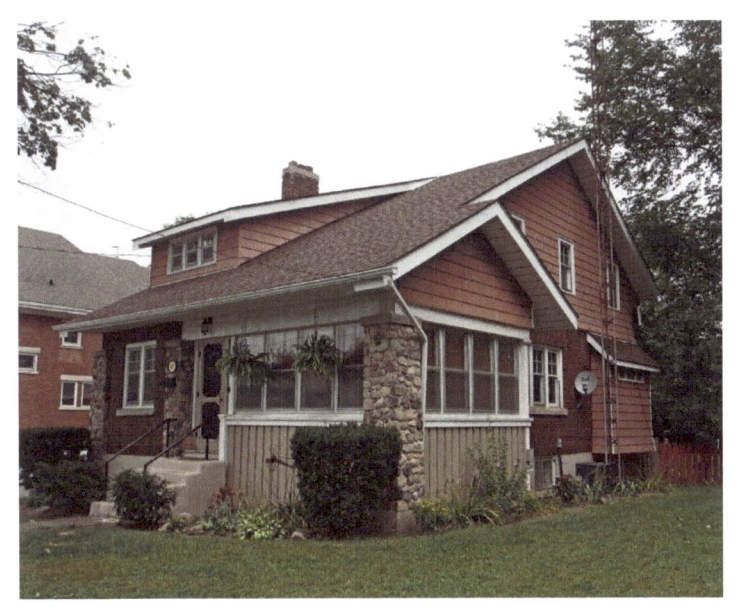

Vernacular

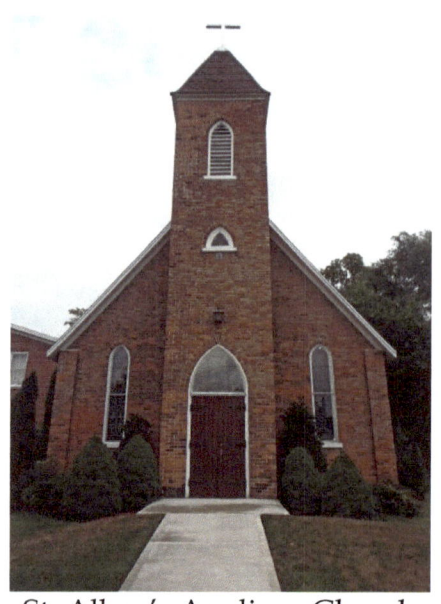

St. Alban's Anglican Church

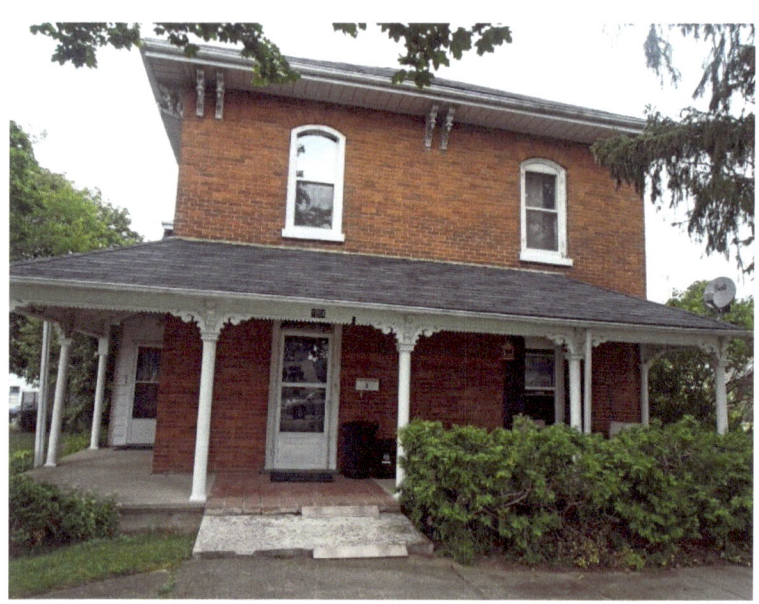

#104 - Italianate, paired cornice brackets, intricate woodwork on veranda

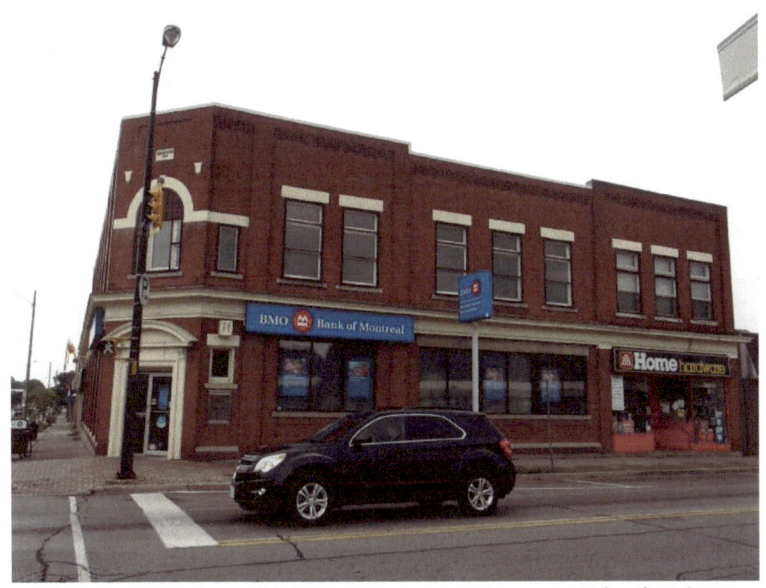

Talbot Road and Main Street – Morgan Block 1914, bevelled dentil moulding

Patterned brickwork

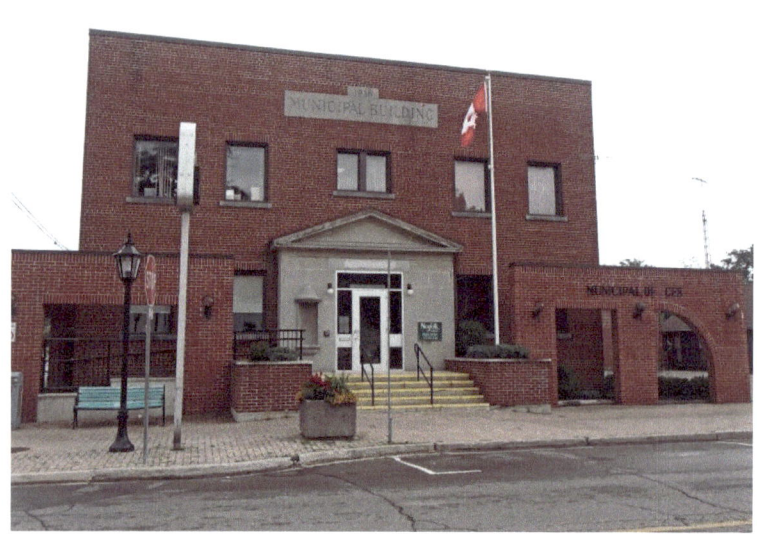

Municipal Building 1936 - pediment

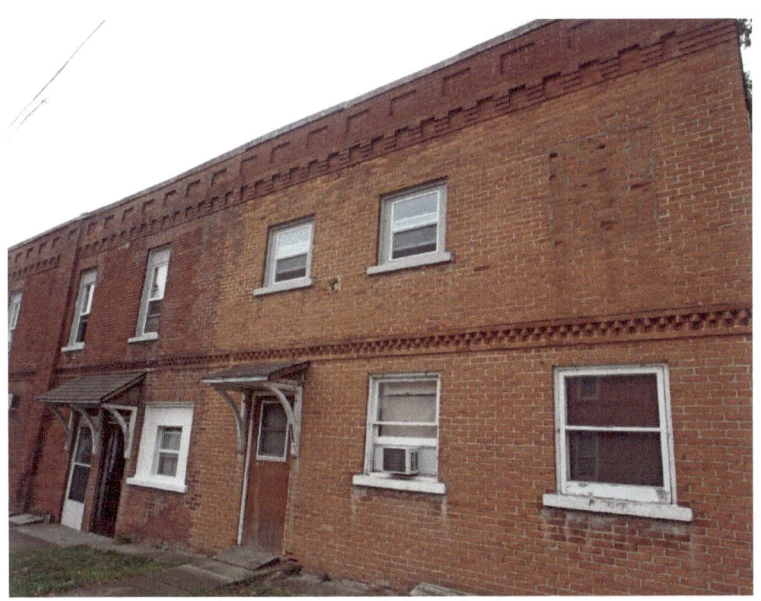

Bevelled dentil moulding below cornice,
dentil moulding dividing the two storeys

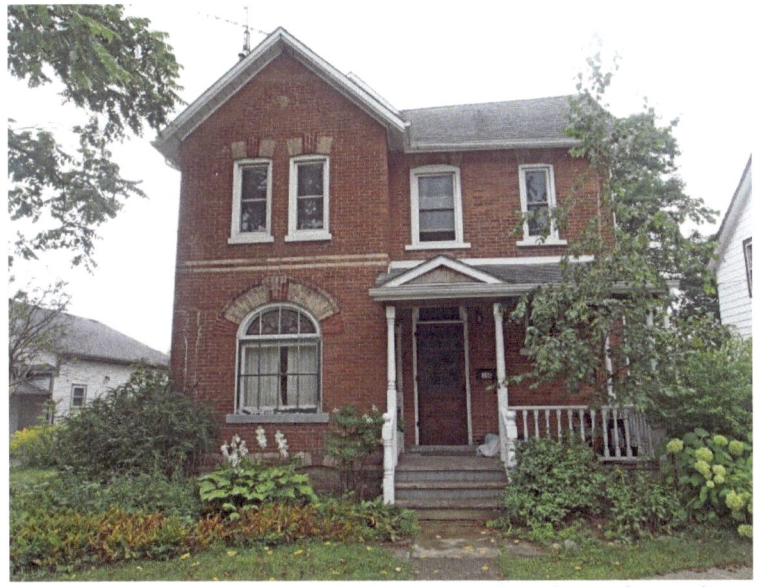

Gothic Revival, banding, dichromatic brickwork, pediment

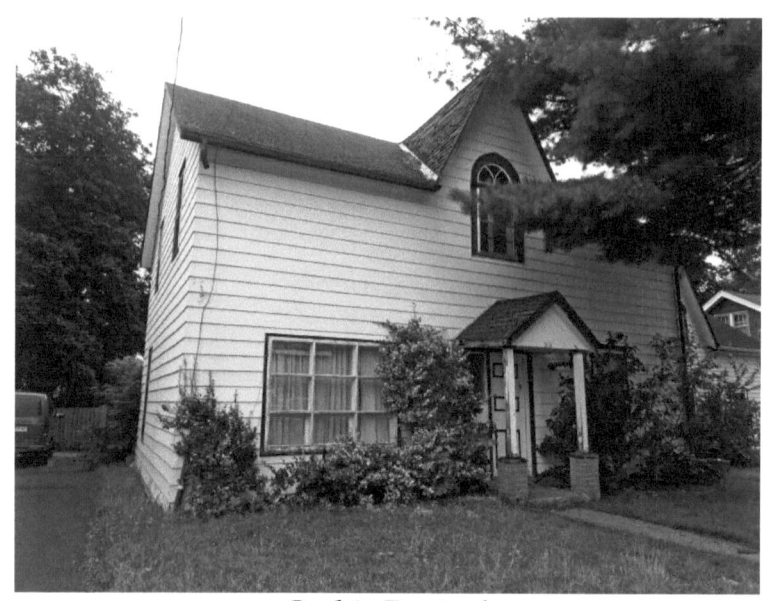

Gothic Revival

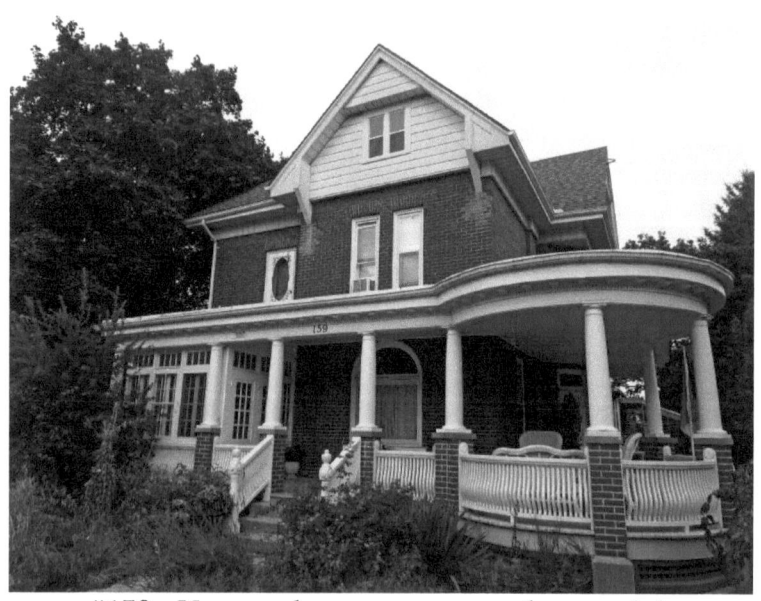

#159 - Vernacular – wraparound verandah

Gothic revival

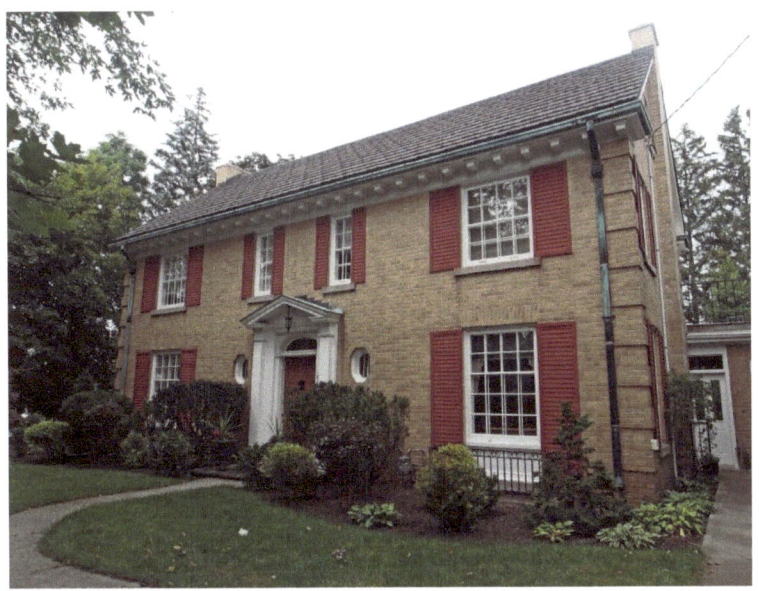

#187 – Georgian – fanlight (transom window) above door

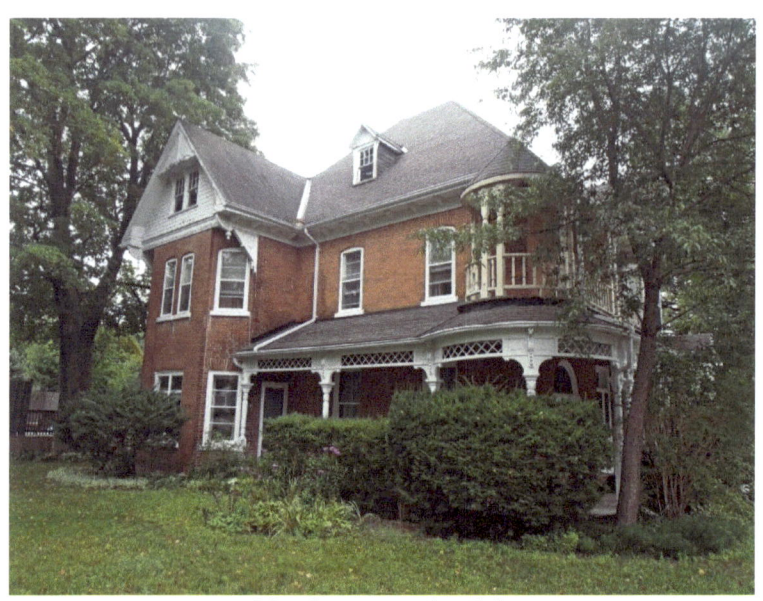
#180 – heritage building
Second floor wraparound verandah with cone-shaped roof with turned spindles, fretwork, dormer, bay window

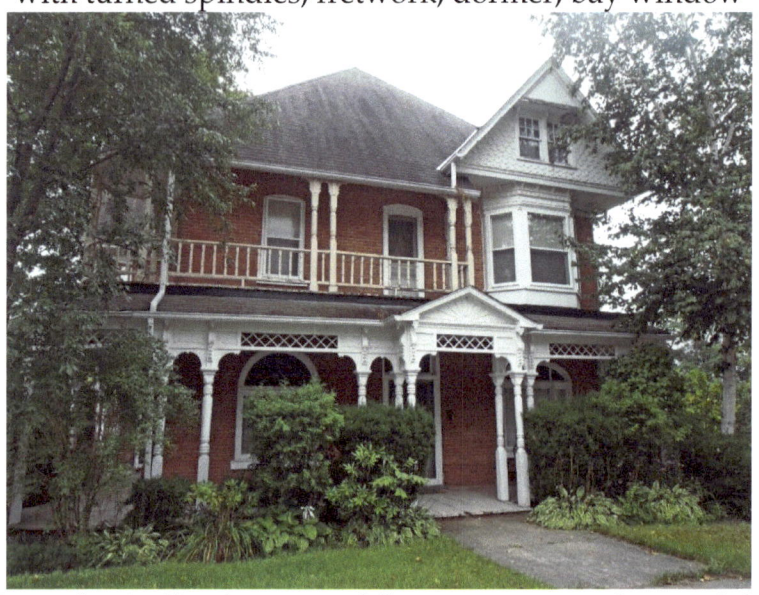
Turned spindles for ground floor wraparound verandah, second floor bay window, pediment

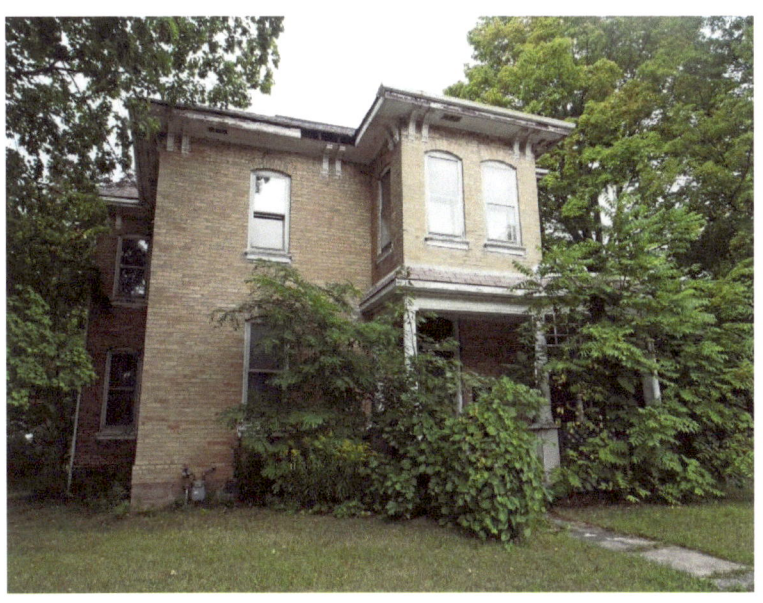

Italianate, paired cornice brackets

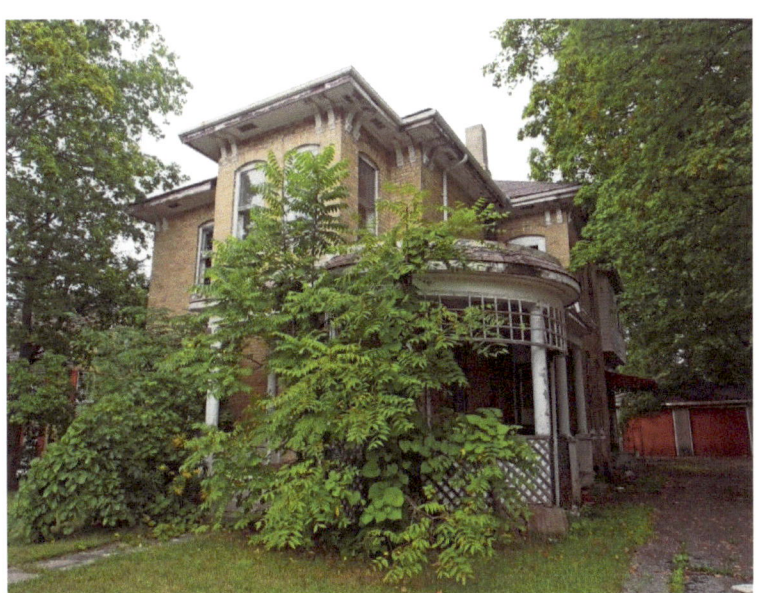

Wraparound verandah

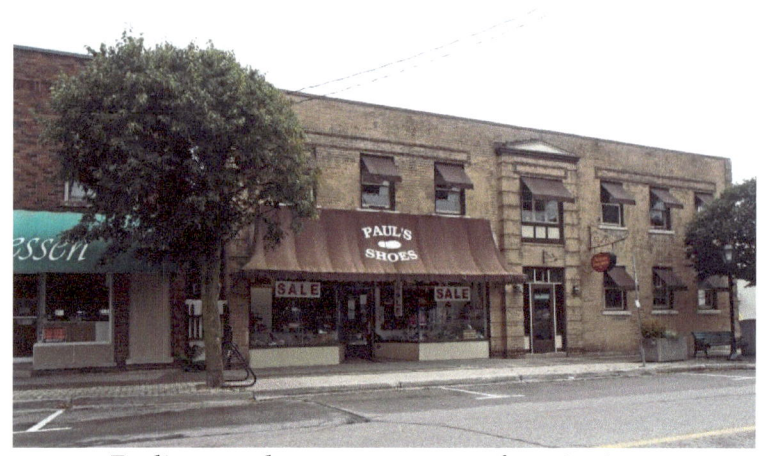
Pediment above two-storey frontispiece

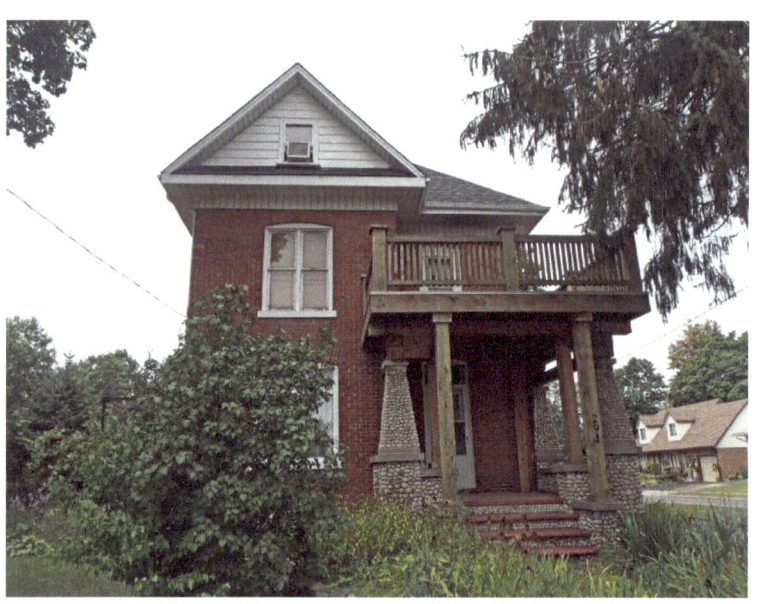
Edwardian – second floor balcony

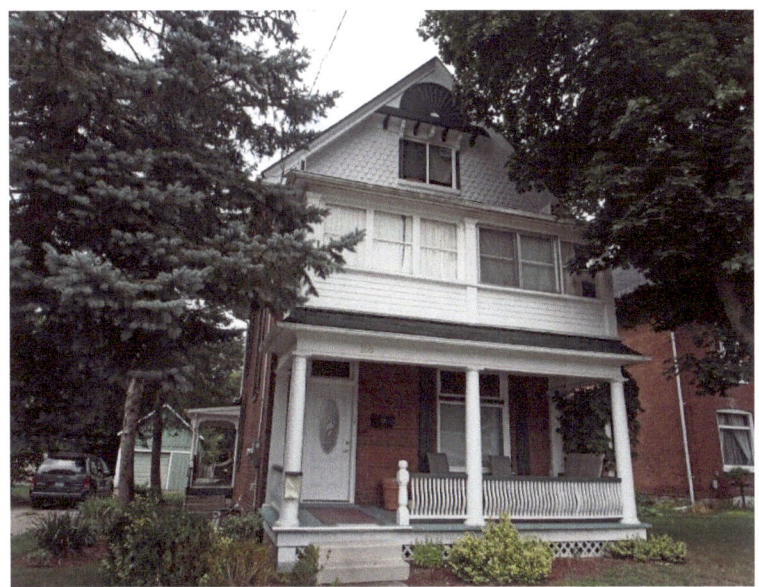

Vernacular

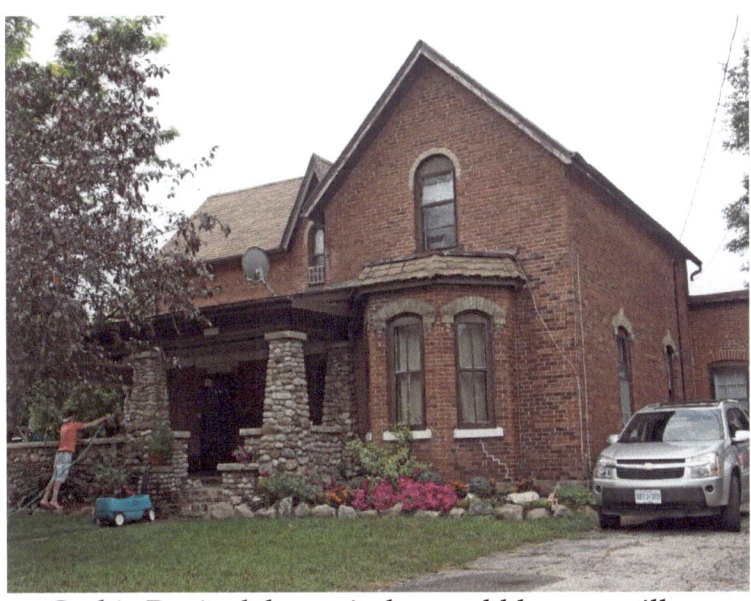

Gothic Revival, bay window, cobblestone pillars

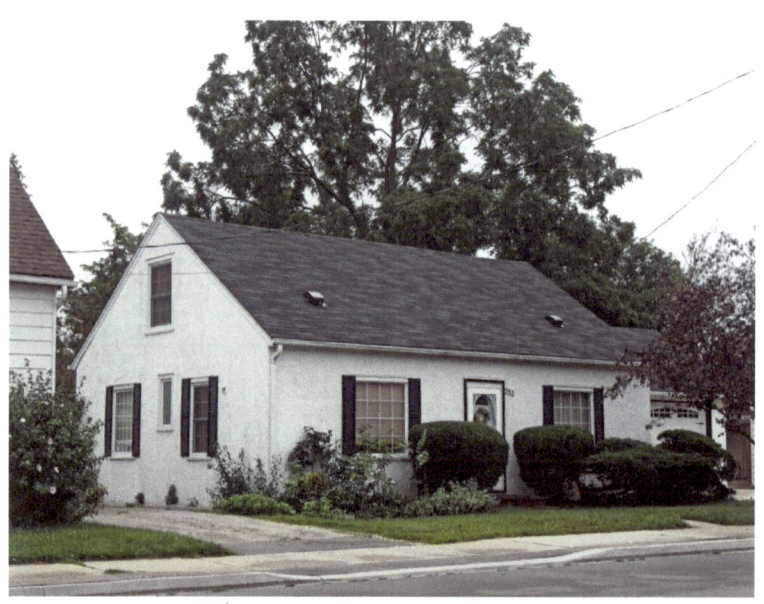
1½ storey Regency Cottage

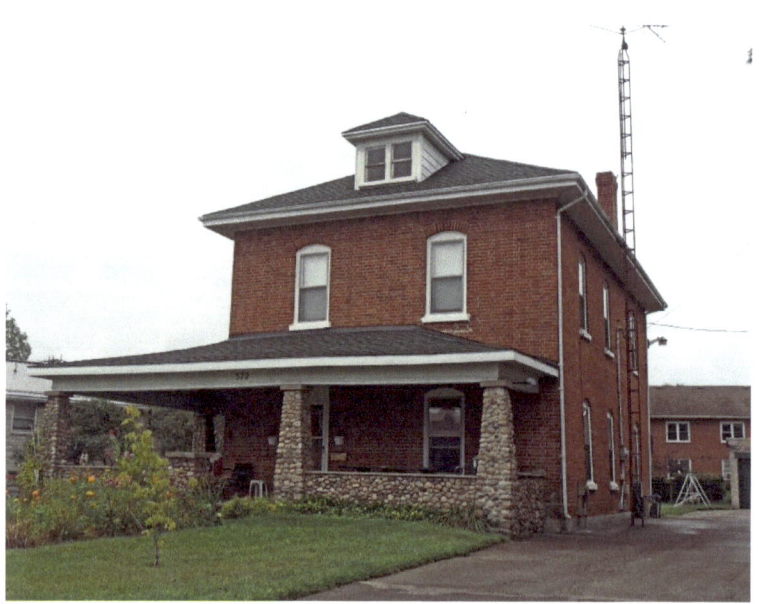
Italianate, hipped roof, dormer

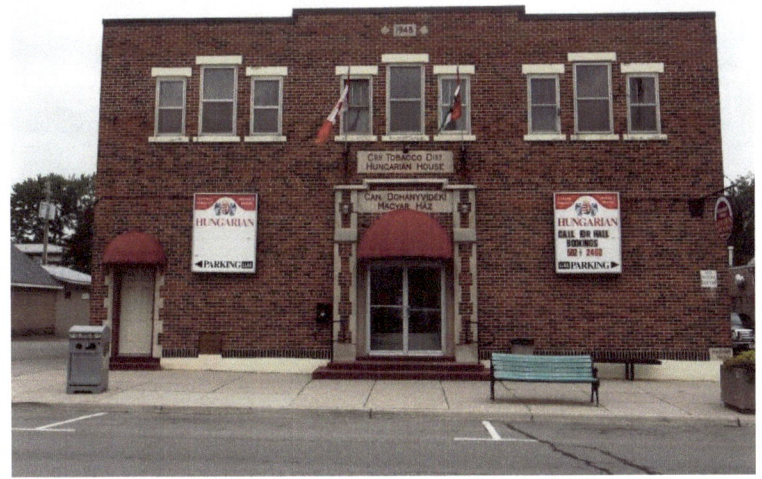

Canadian Tobacco District Hungarian Building - 1948

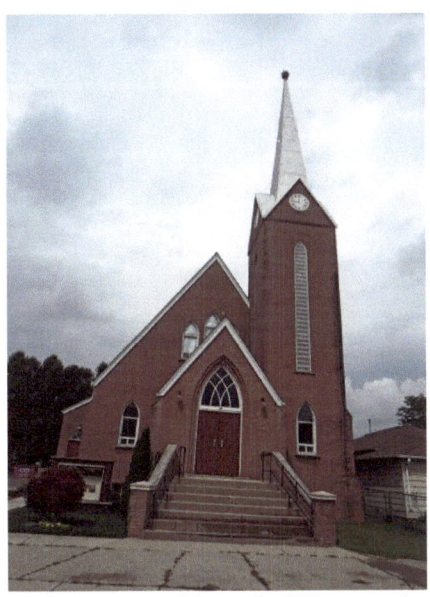

Calvin Presbyterian Church (Hungarian) – 1950

Port Ryerse

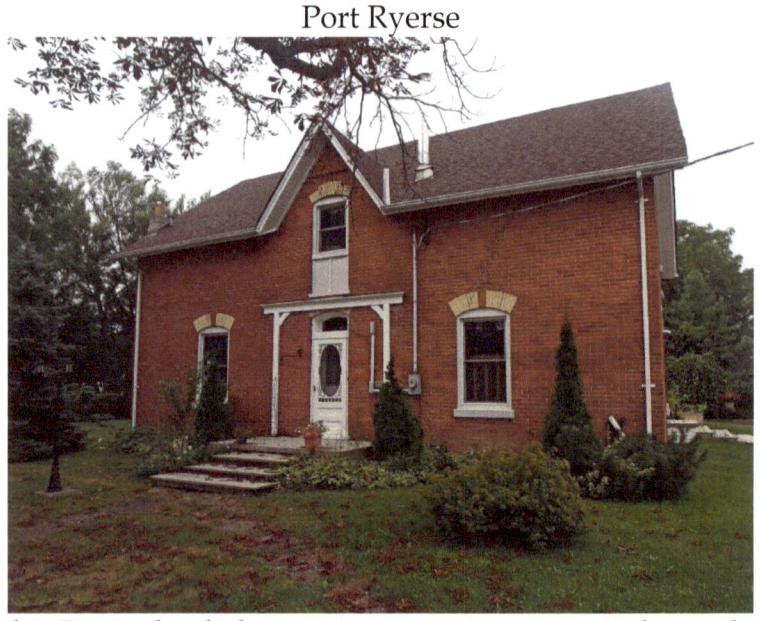

Gothic Revival – dichromatic voussoirs over windows, dentil moulding above gable window

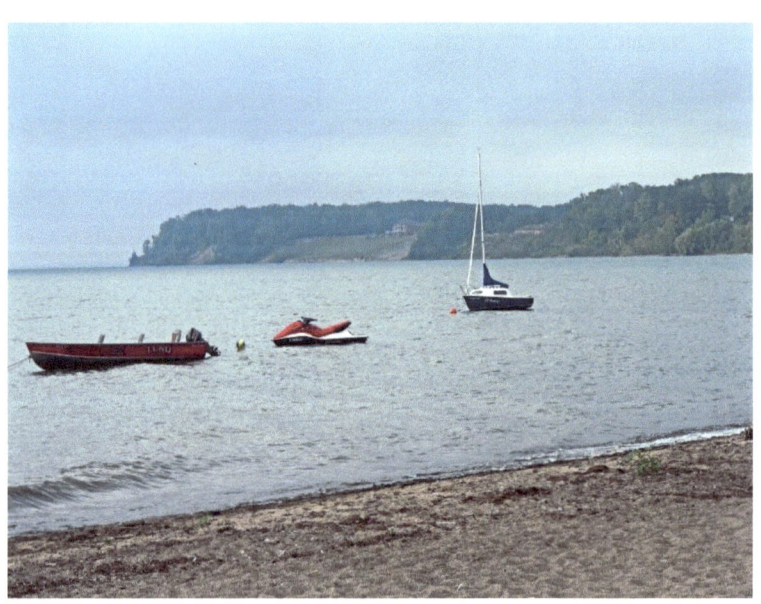

Wood cabin

dormer

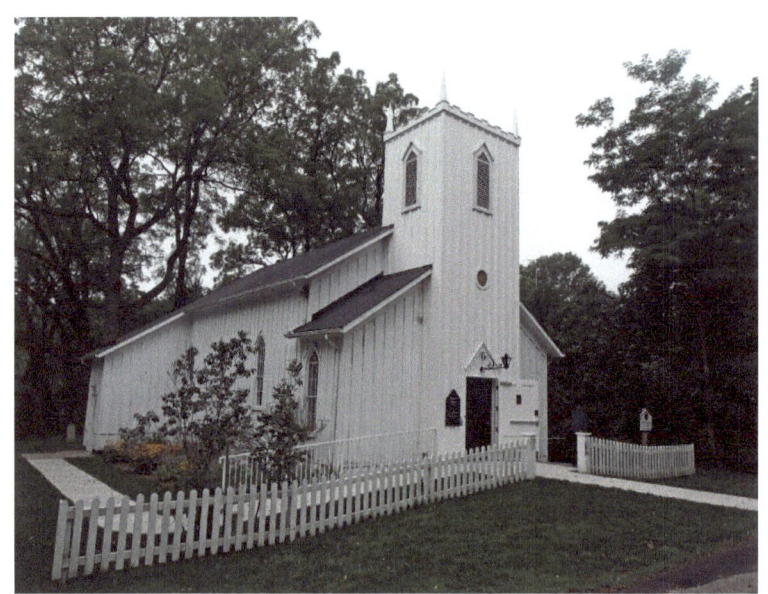

Anglican Memorial Church established 1870

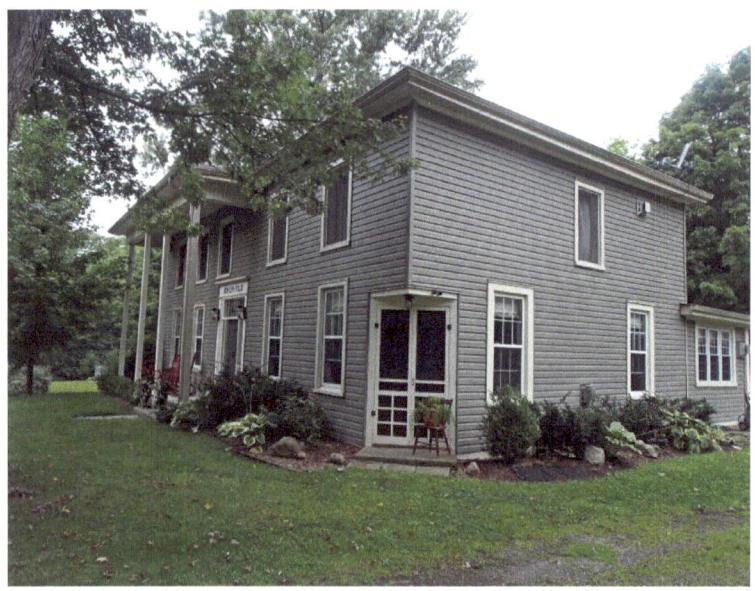

Idylwyld

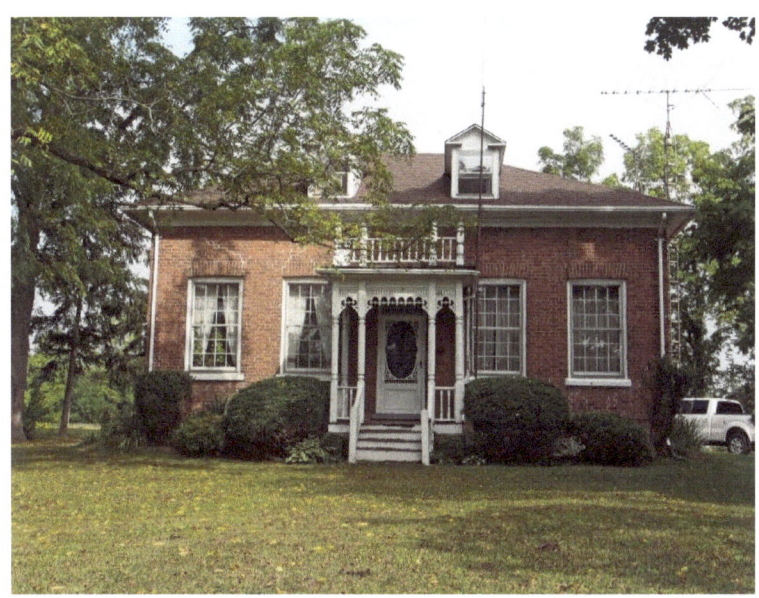

Italianate, hipped roof, dormers, second floor balcony, Turned spindles and intricate woodwork for entrance

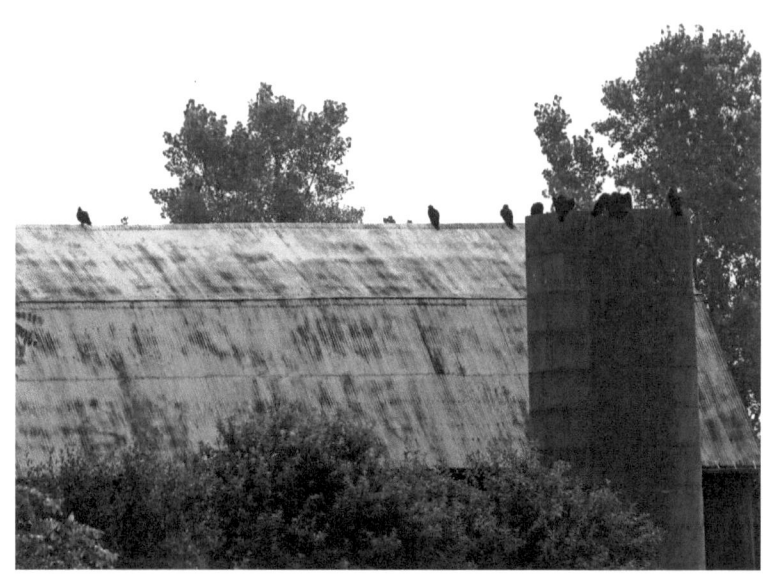

Gathering of turkey vultures

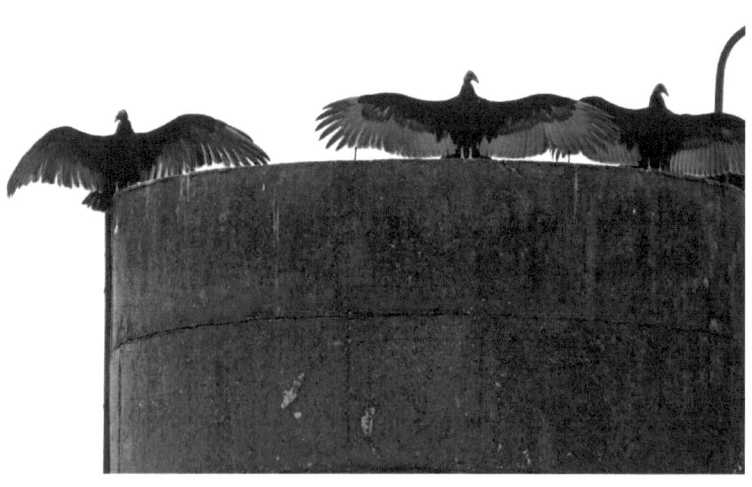

Fishers Glen

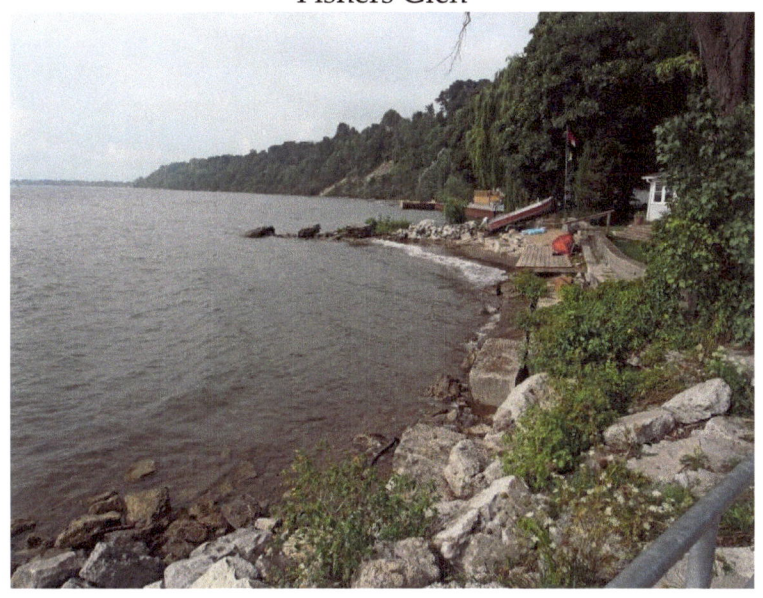

Normandale

Board and batten, verge board trim on gable

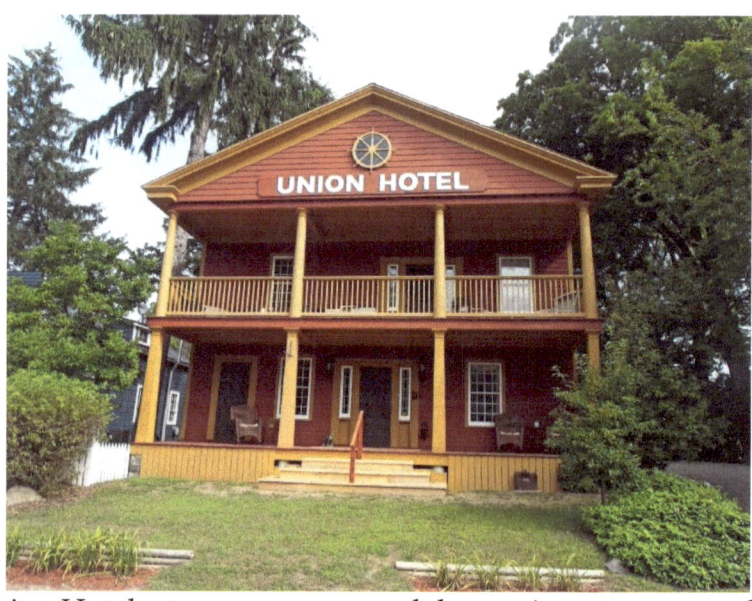

Union Hotel – two-storey verandah, cornice return on gable

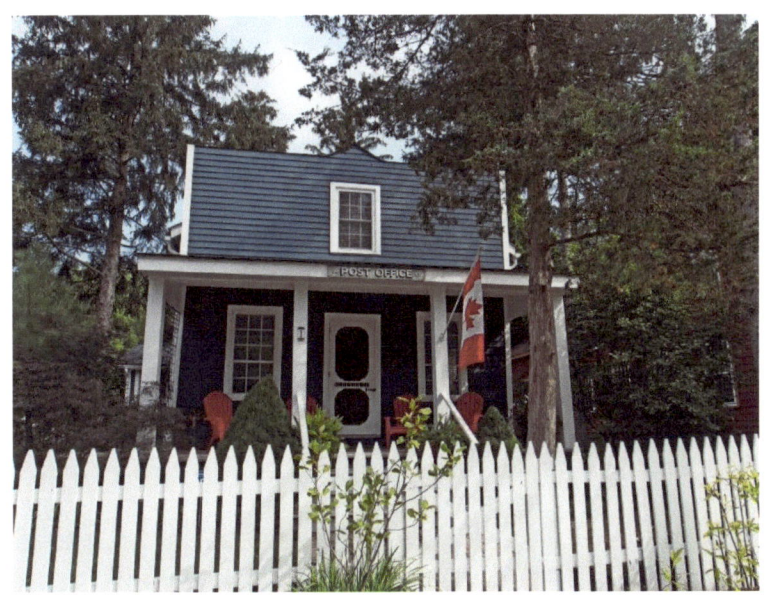

Post Office

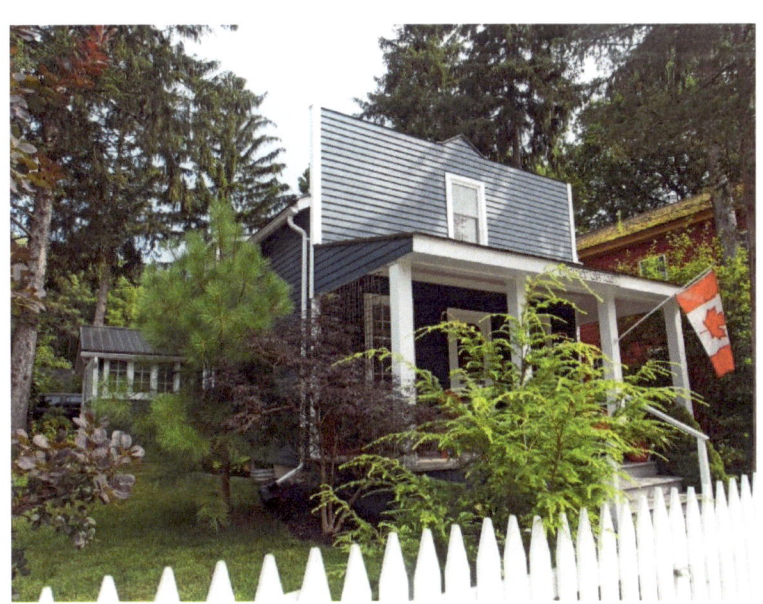

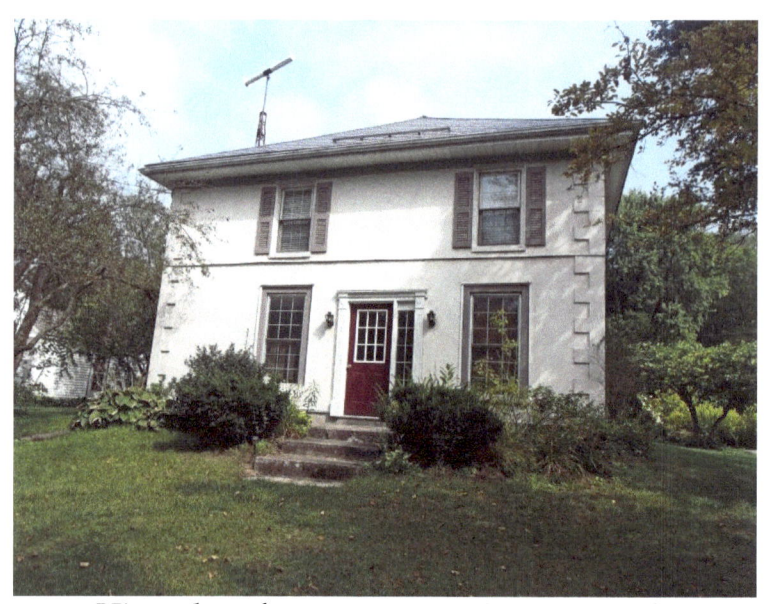

Hipped roof, corner quoin, Georgian style

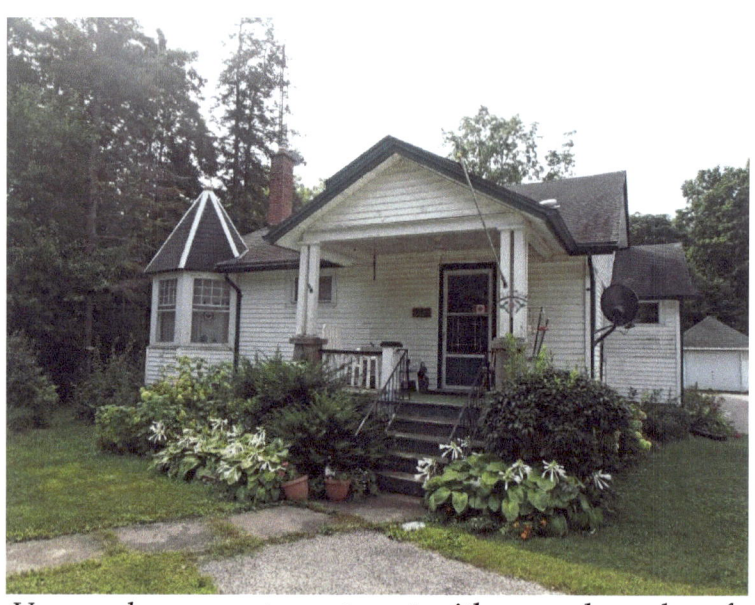

Vernacular - one-storey turret with cone shaped roof, pediment

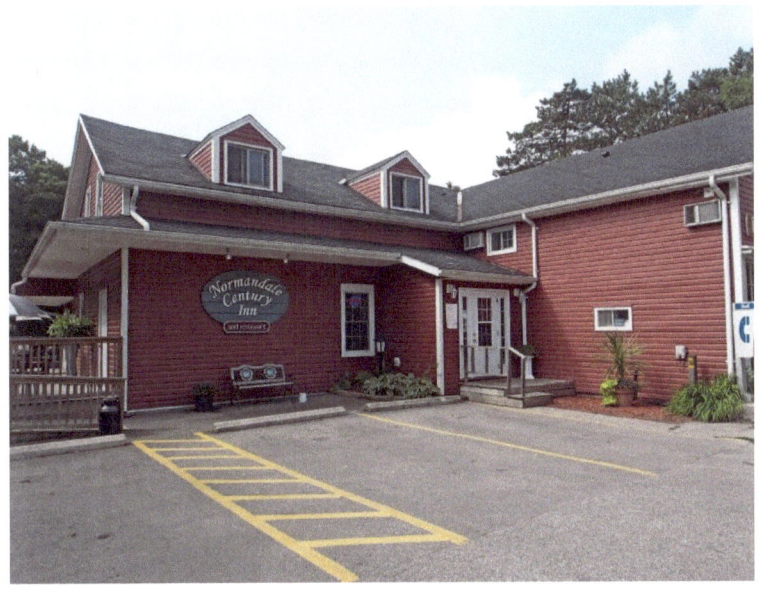

Dormers

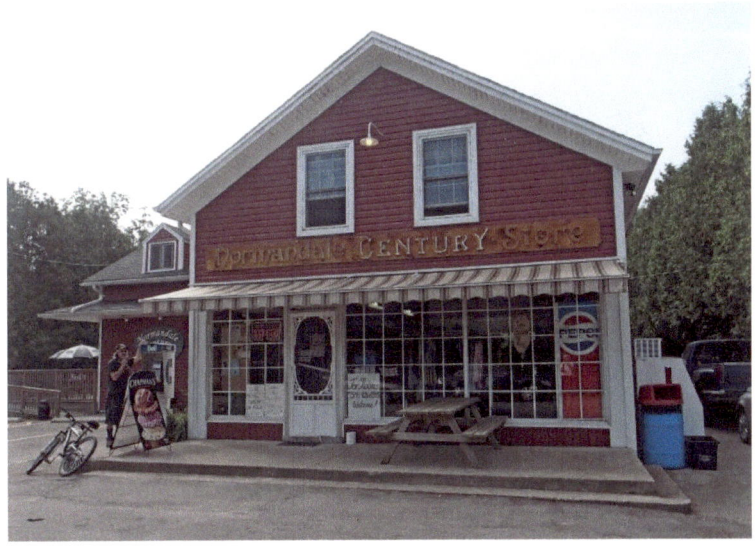

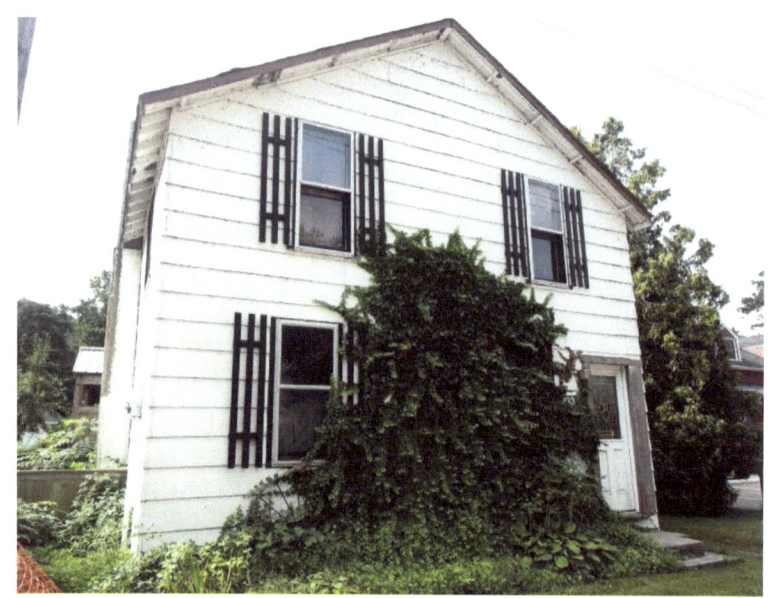

Gothic

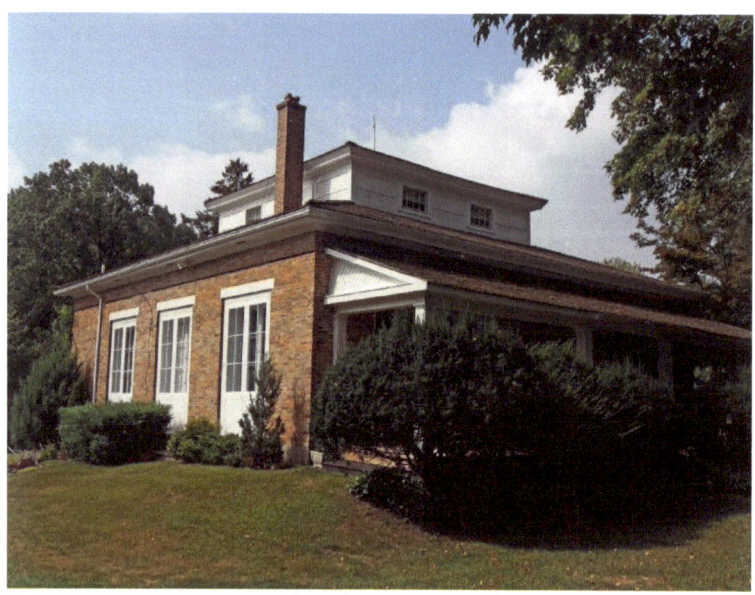

Belvedere on roof

Turkey Point

LaSalette

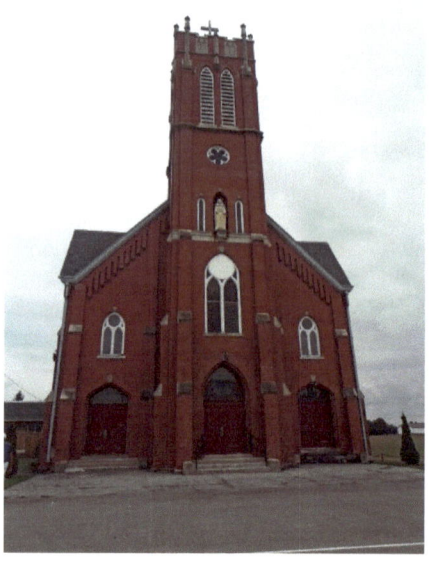

LaSalette Historic Church – rebuilt A.D. 1914 – Gothic Revival

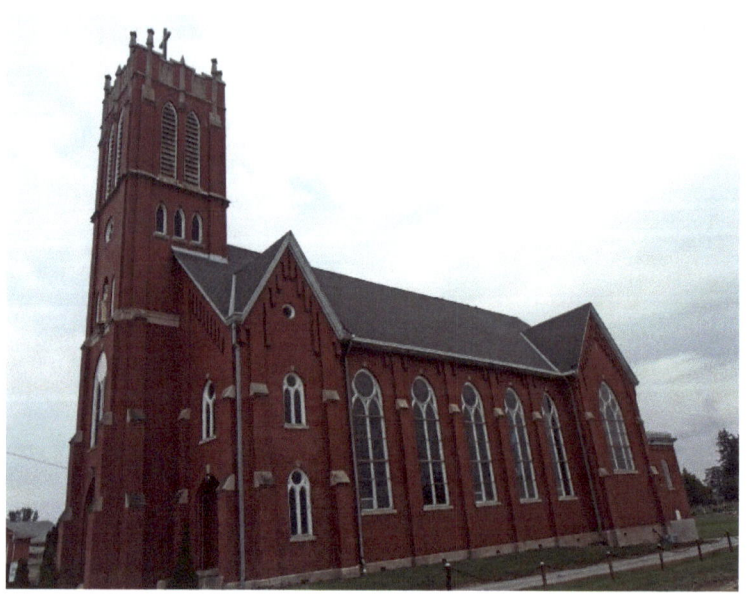

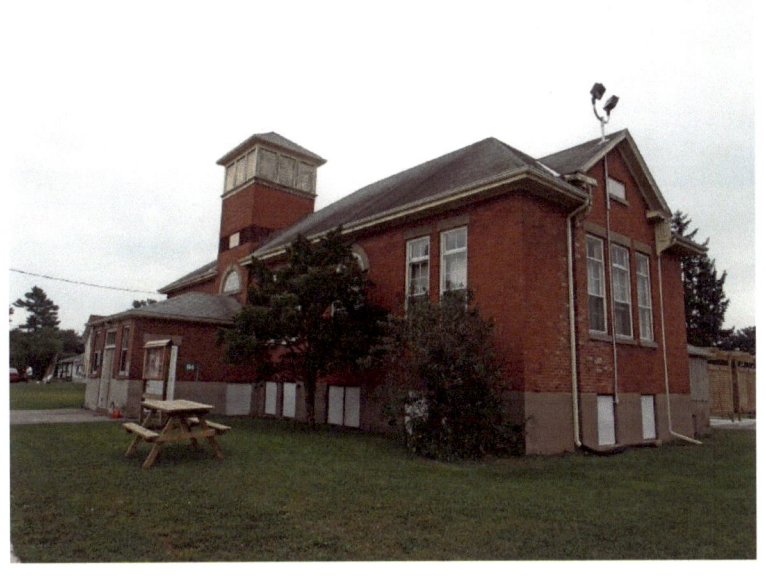

St. Mary's School and Hall A.D. 1906

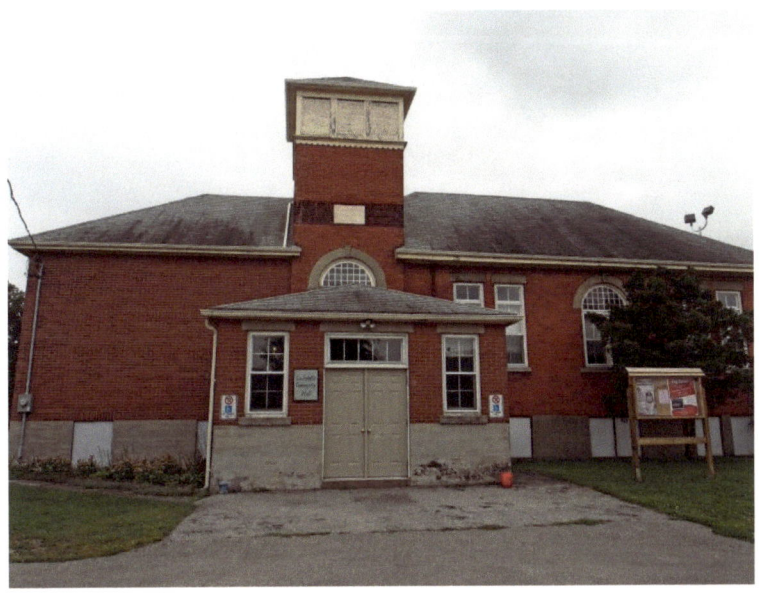

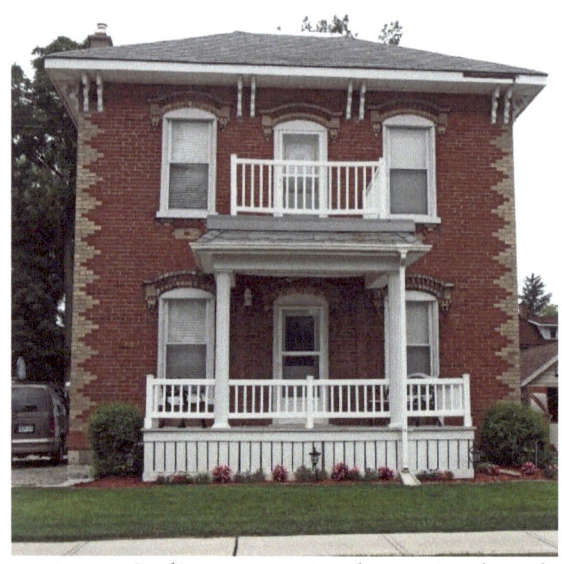

Two-storey Italianate, paired cornice brackets,
2nd floor balcony, corner quoins,
elegant voussoirs over windows and door

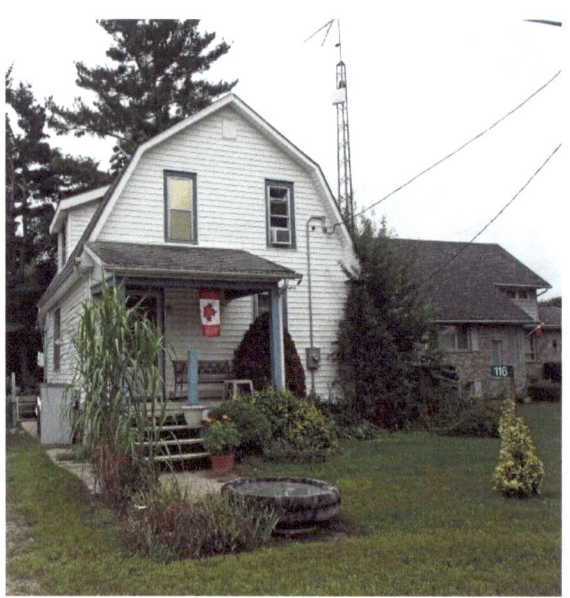

Cape Dutch style of architecture

Windham Centre

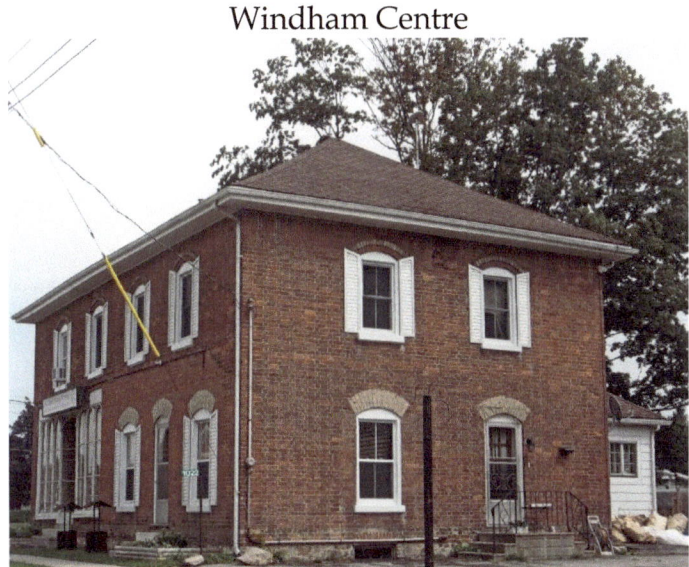

Hipped roof

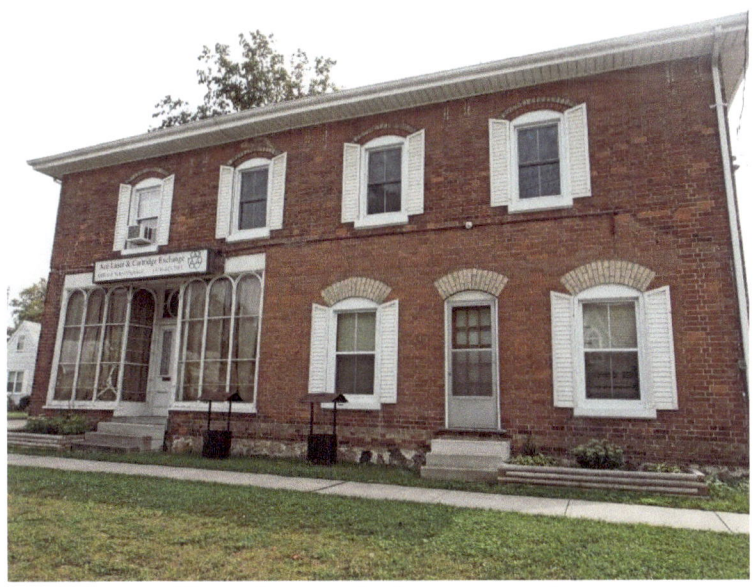

Georgian – window voussoirs

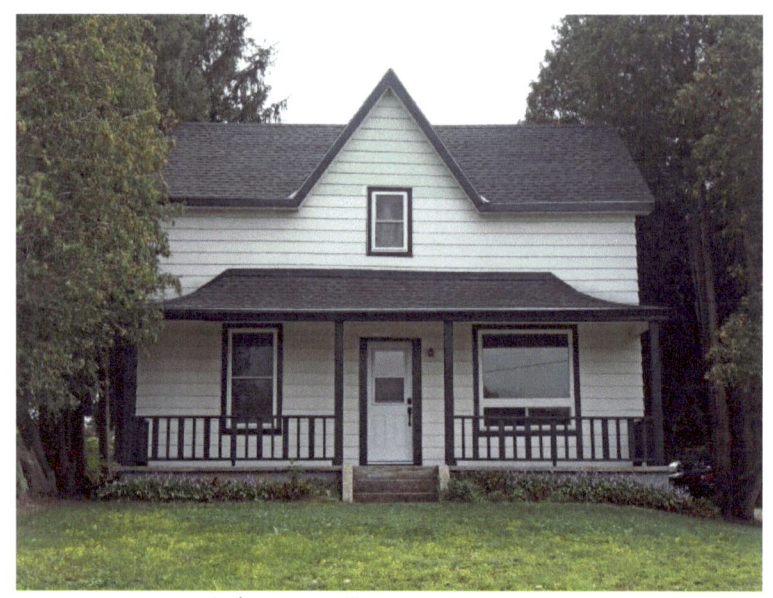

1½ storey Regency cottage

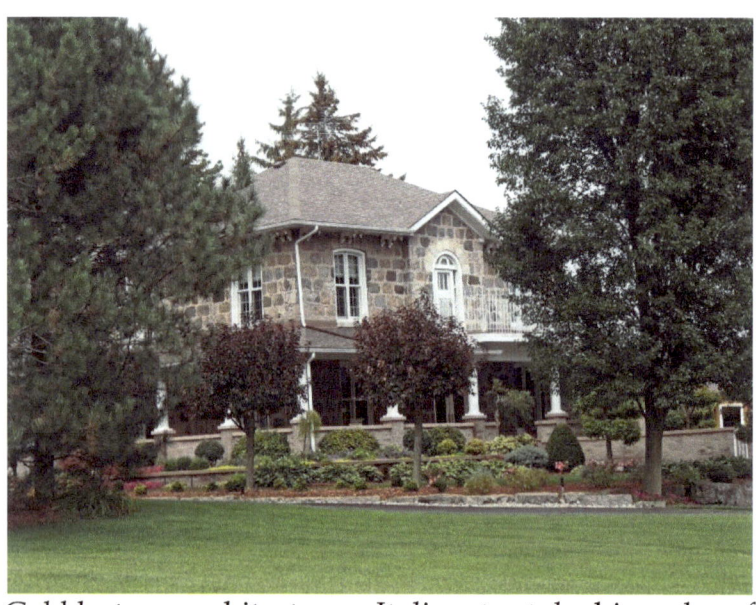

Cobblestone architecture – Italianate style, hipped roof

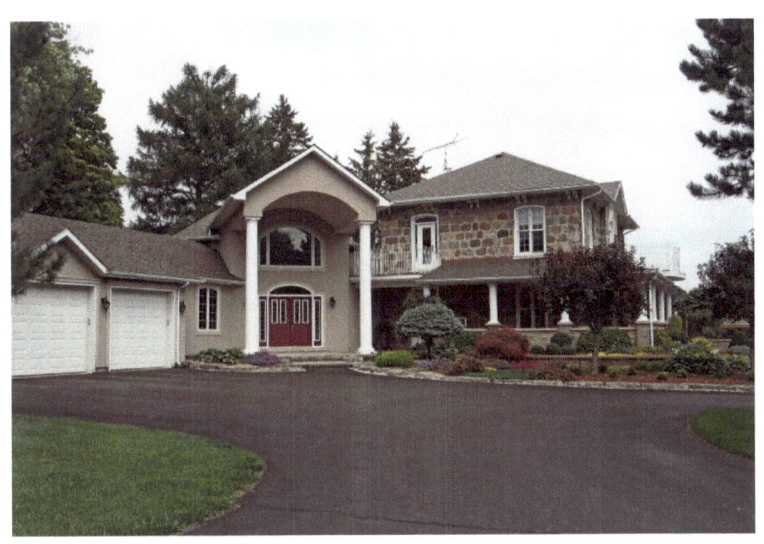

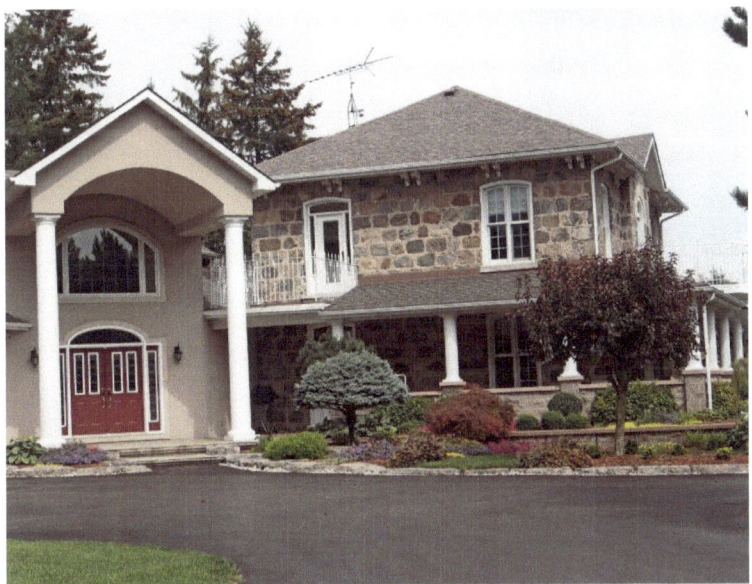

Paired cornice brackets

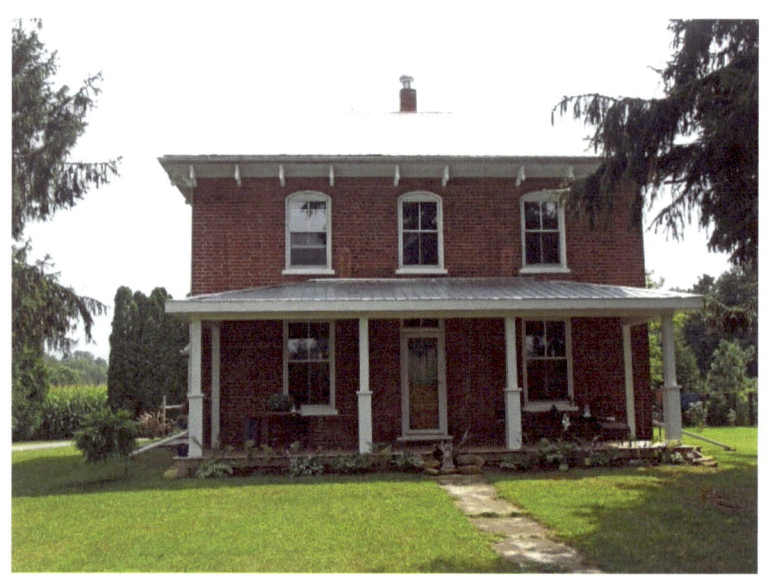
Italianate, single cornice brackets, hipped roof

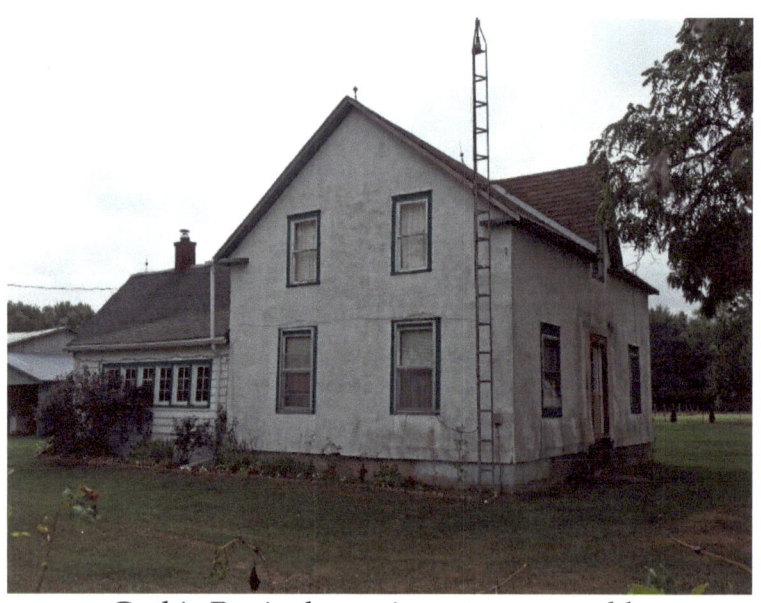
Gothic Revival, cornice return on gable

Lynnville

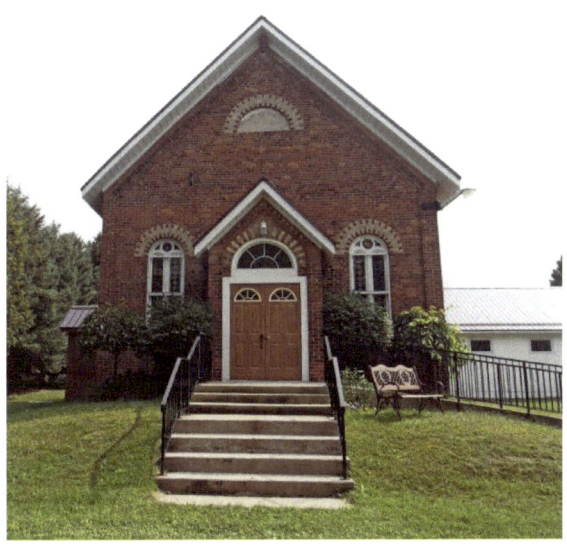

Lynnville United Church

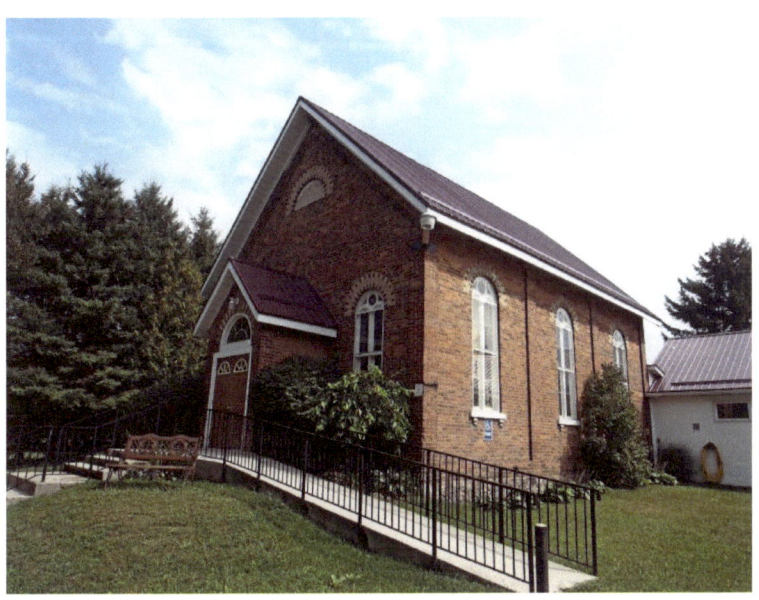

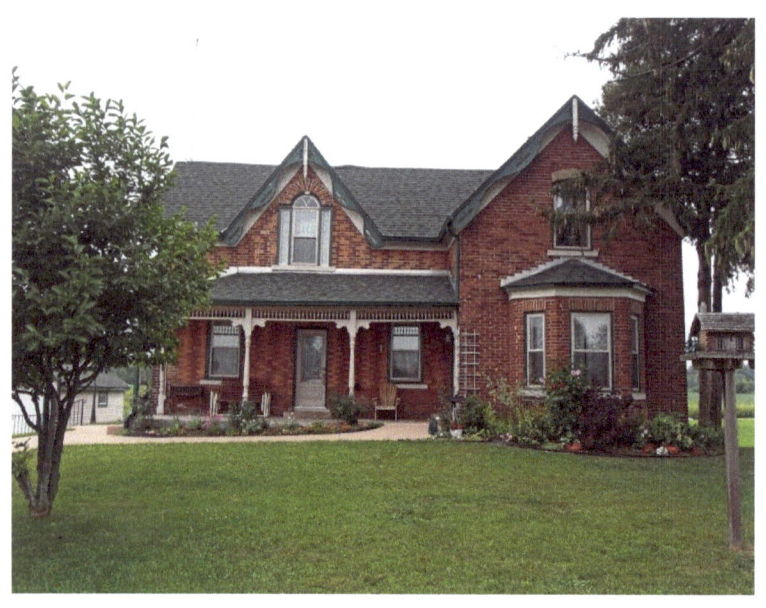

Gothic Revival, verge board trim and finial on gables, bay window, turned spindles on verandah

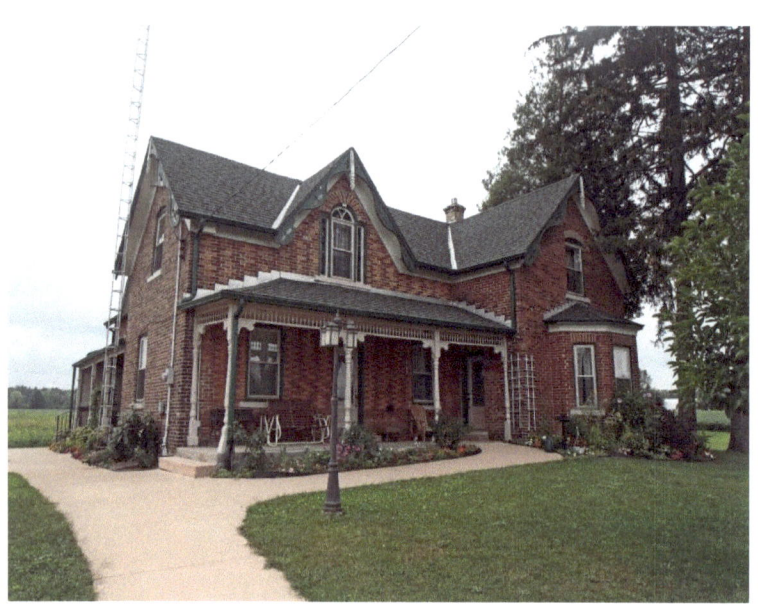

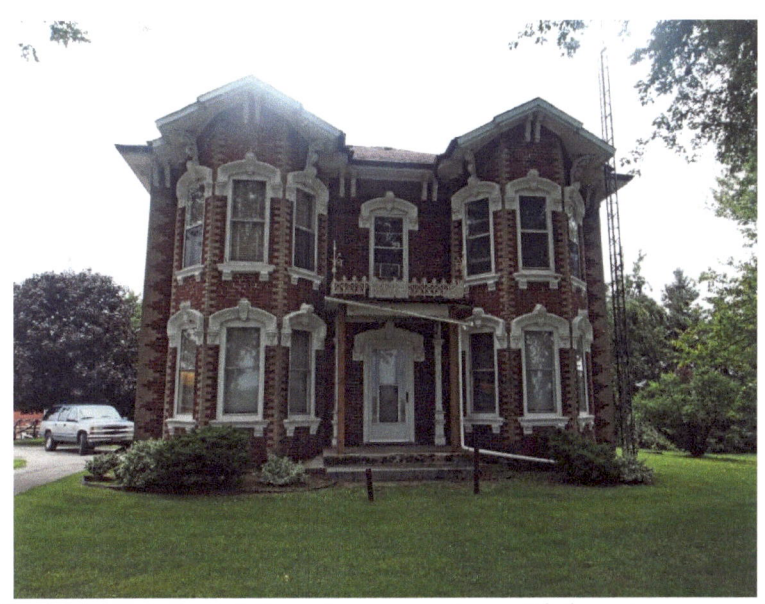

Victorian style - elaborate voussoirs with keystones over windows and door, iron cresting on 2nd floor balcony, corner quoins, cornice brackets

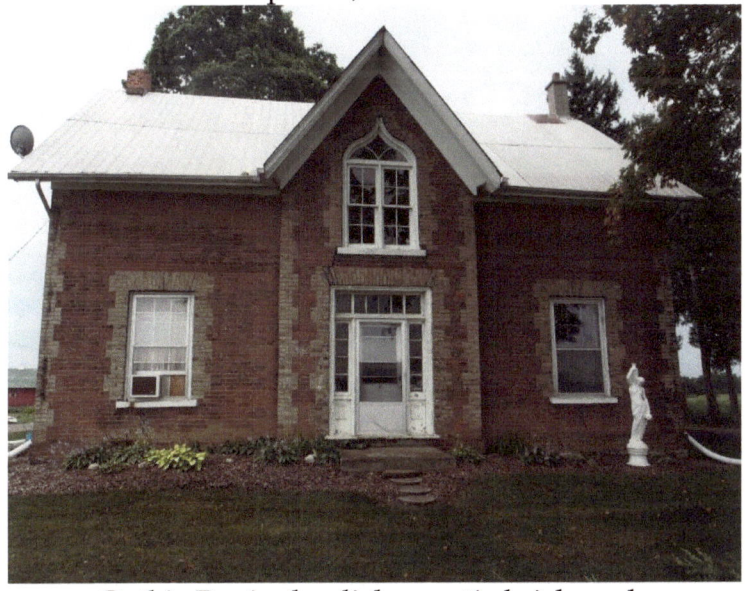

Gothic Revival – dichromatic brickwork, Sidelights, transom window

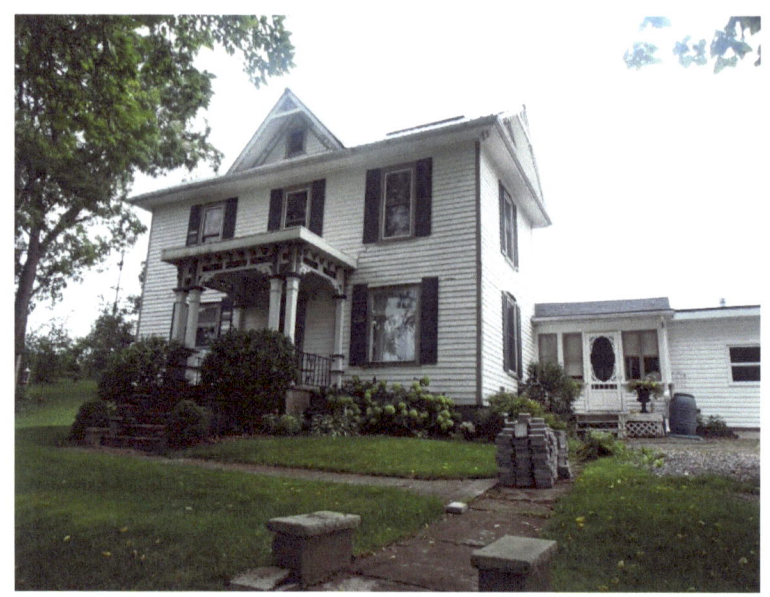

Gothic Revival – intricately carved and stenciled entrance

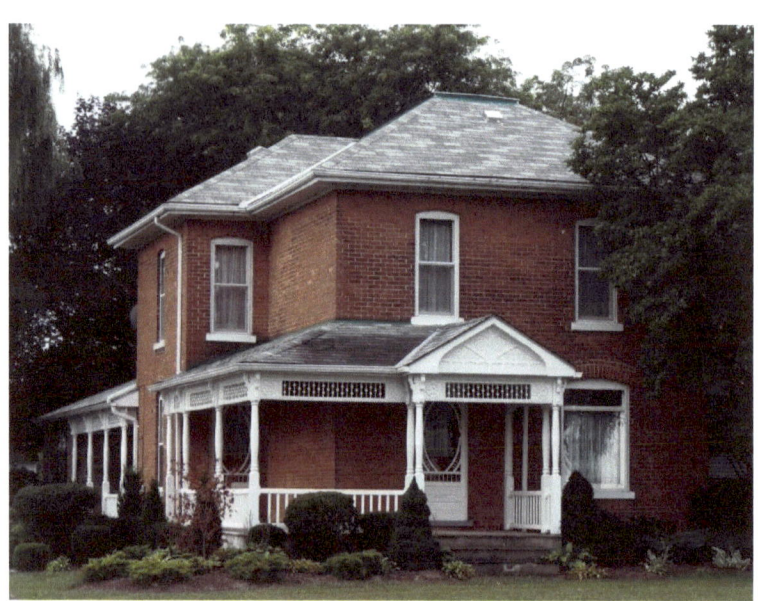

Italianate – hipped roof on front and rear,
pediment above door, wraparound verandah

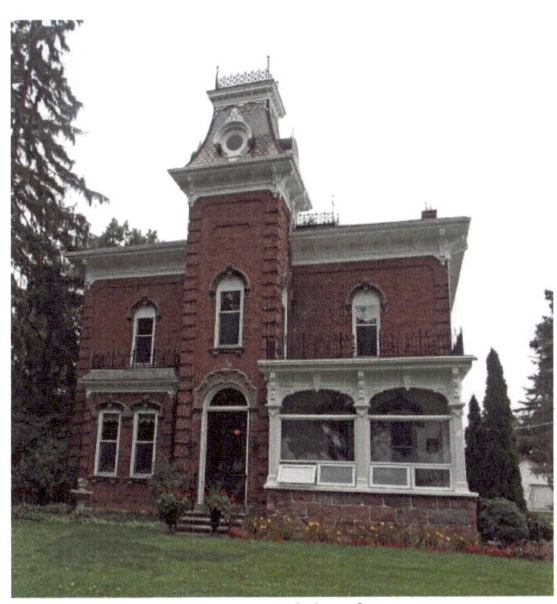

Italianate with 3-storey tower-like frontispiece topped with iron cresting widow's walk, polychromatic tilework on 3rd floor of tower, round windows with window hoods; cornice brackets, corner quoins, window hoods with keystones; iron cresting on main roof as well as on second floor

Concession 4

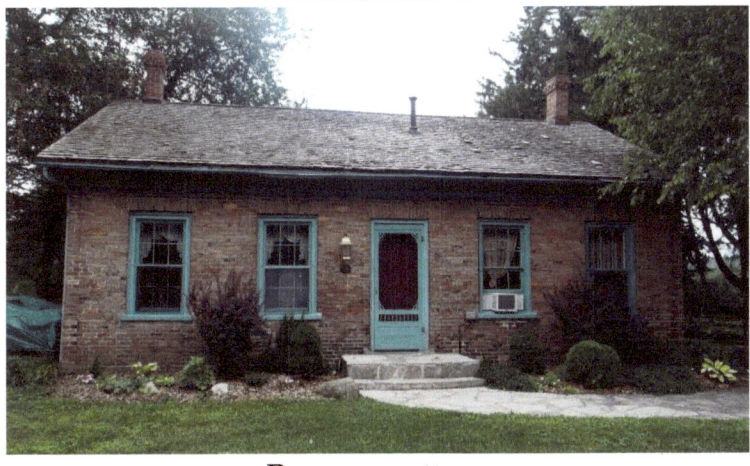

Regency cottage

Gothic

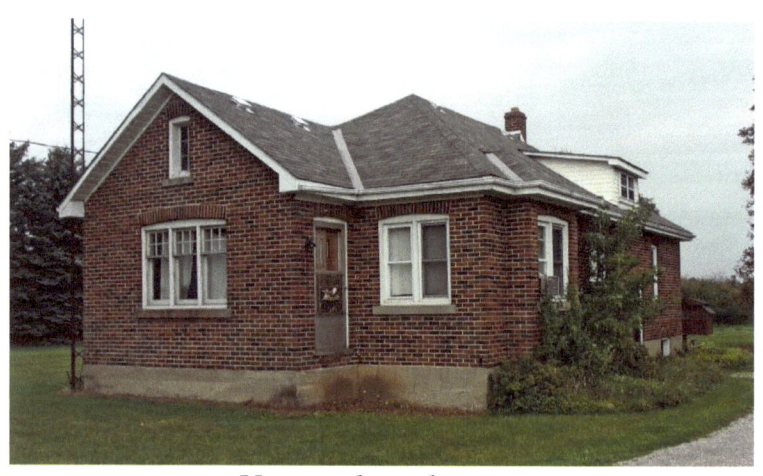

Vernacular - dormer

Concession 14, Townsend, Simcoe

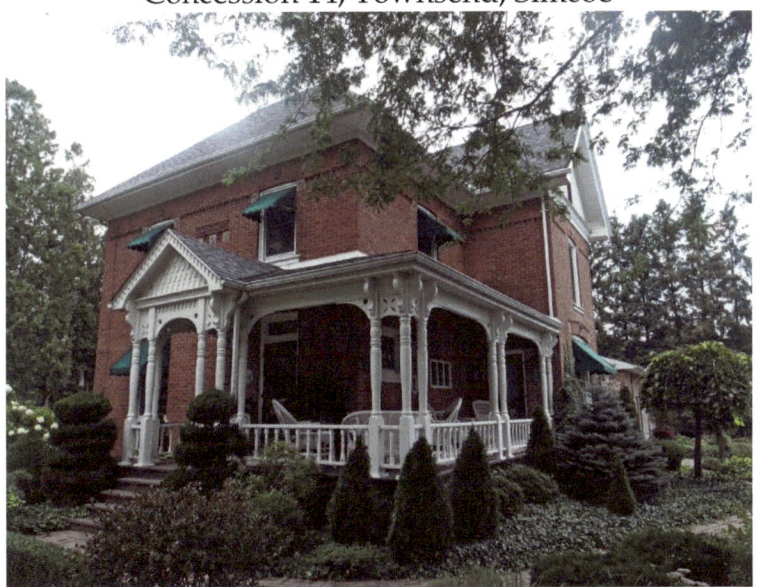

The Country Dollhouse Bed and Breakfast
Dentil moulding, voussoirs with keystones, decorative brickwork

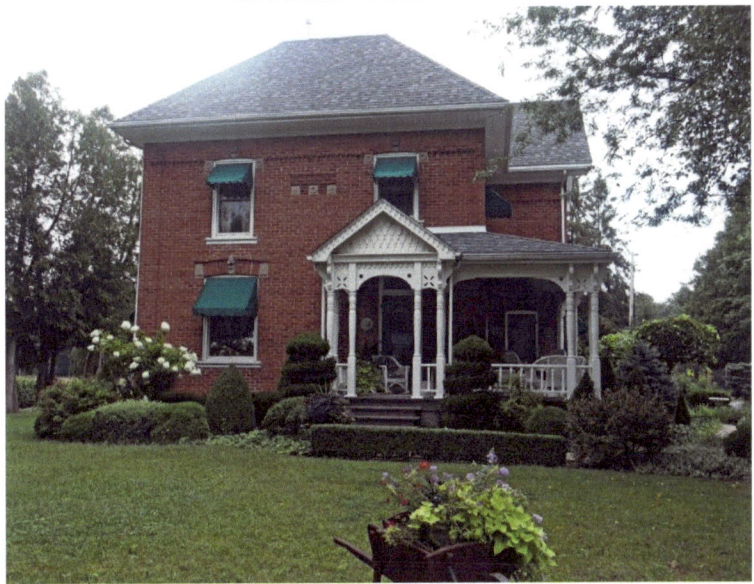

Pediment, turned spindles on verandah, stenciling

Simcoe

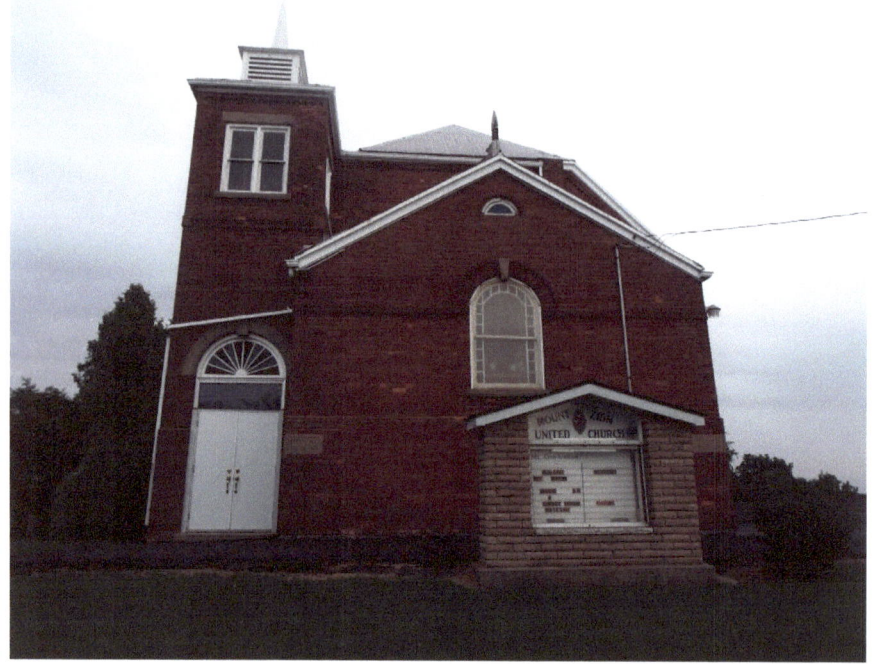

Mount Zion Methodist Church erected June 26, 1902

Wall with hooks for horses

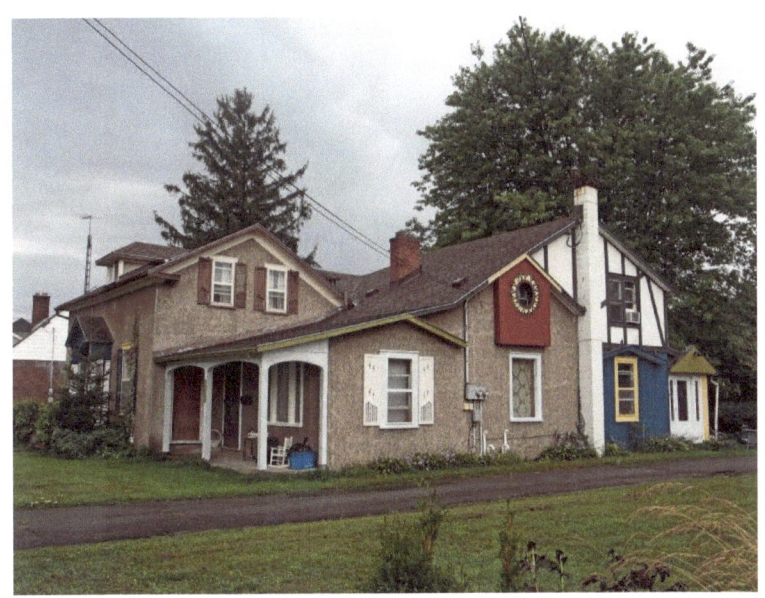

Stucco

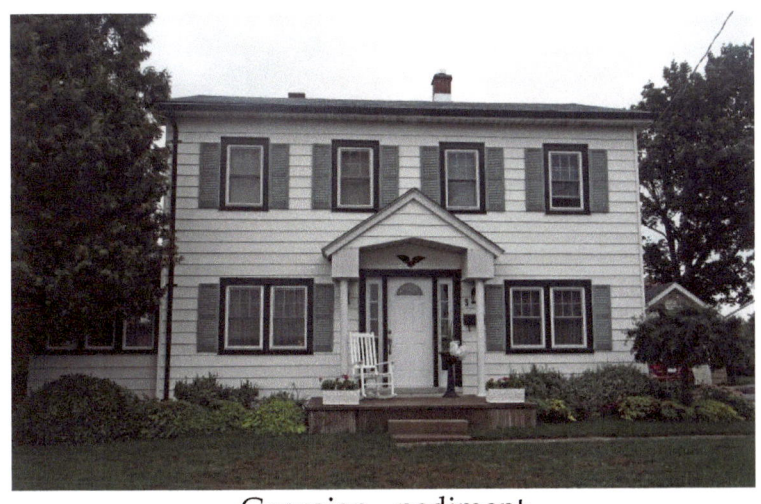

Georgian - pediment

Curries

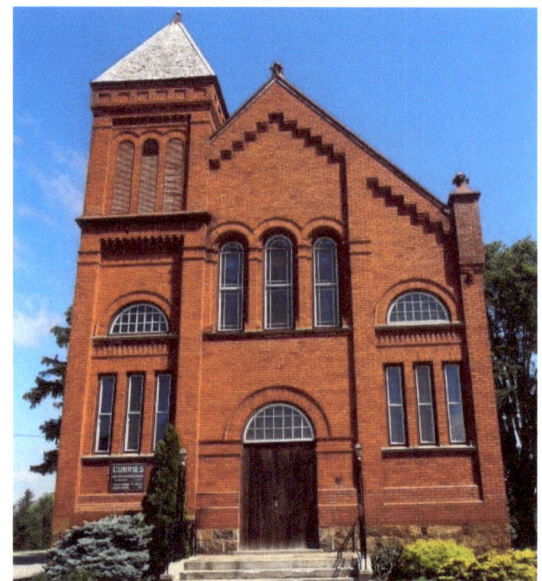

Wesley Memorial Church erected A.D. 1891
Romanesque style - bevelled dentil moulding

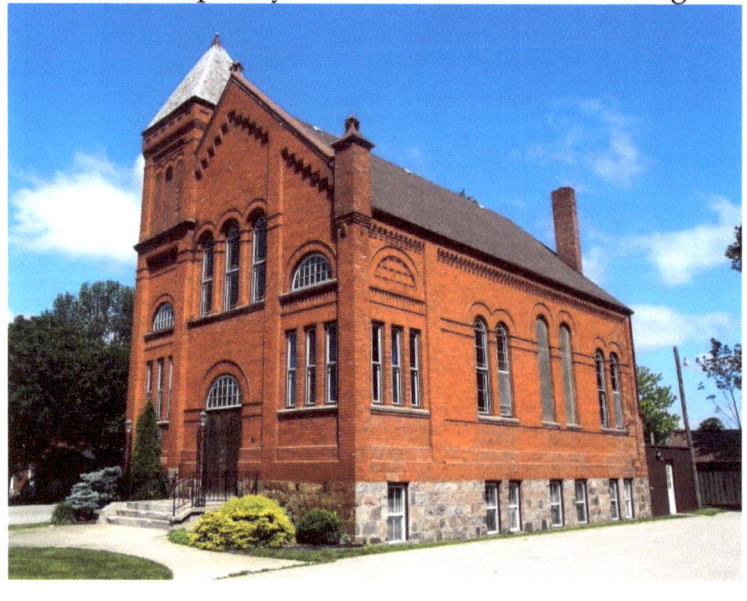

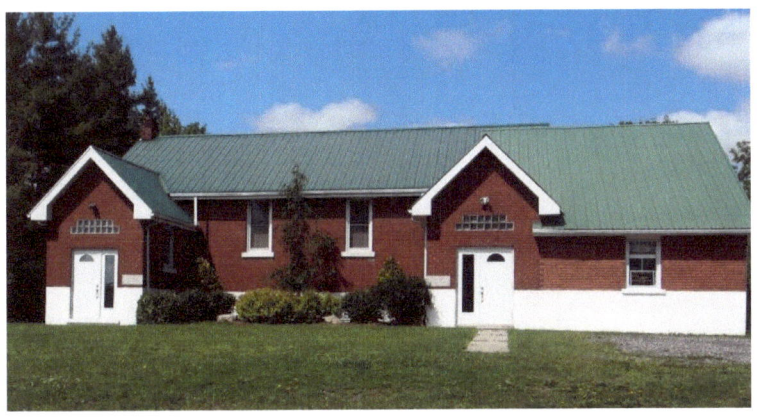

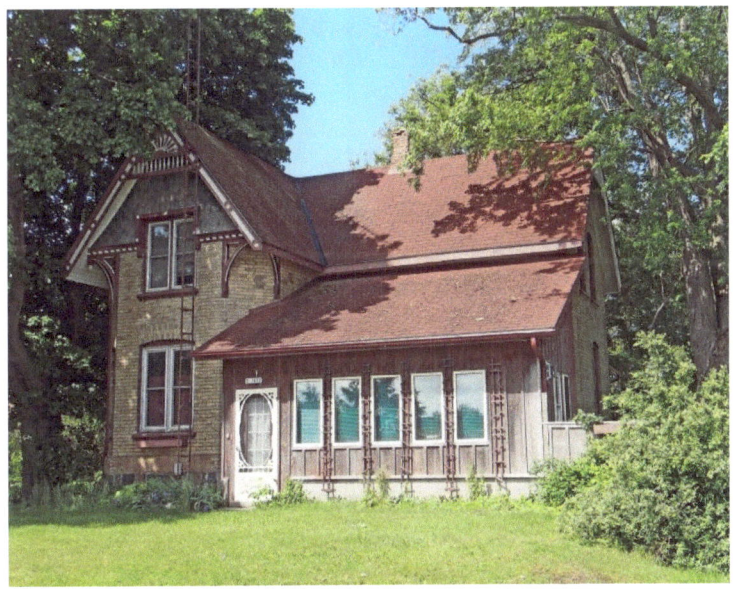

Fretwork, within the peak it is decorated with spindles
c. 1873

Springford

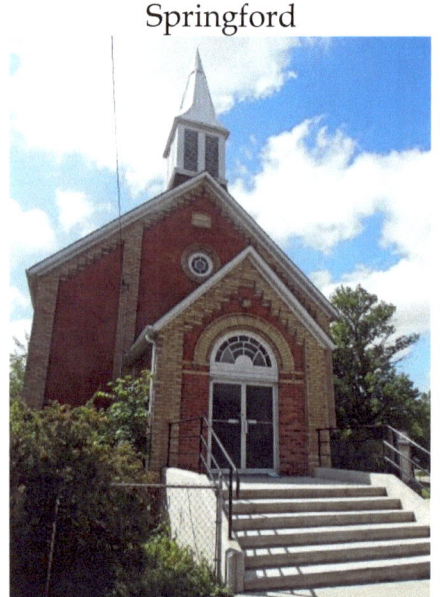

Springford Methodist Church 1894

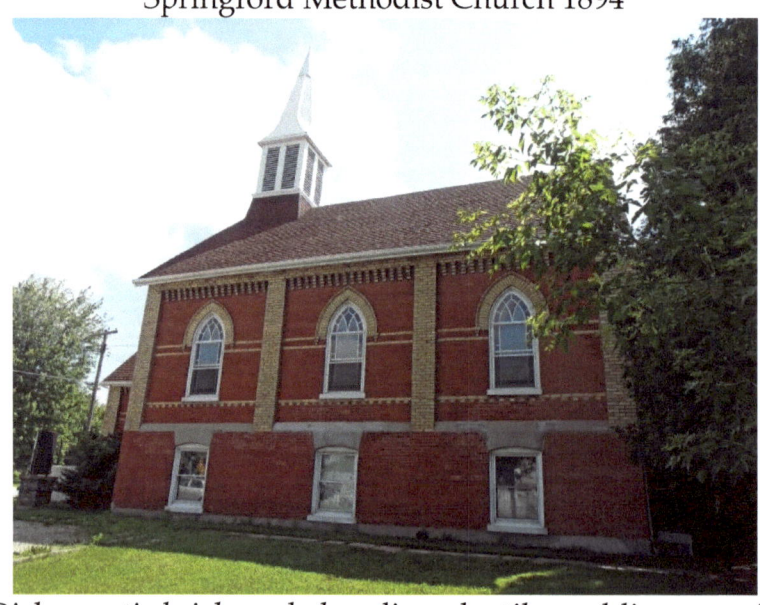

Dichromatic brickwork, banding, dentil moulding, cupola

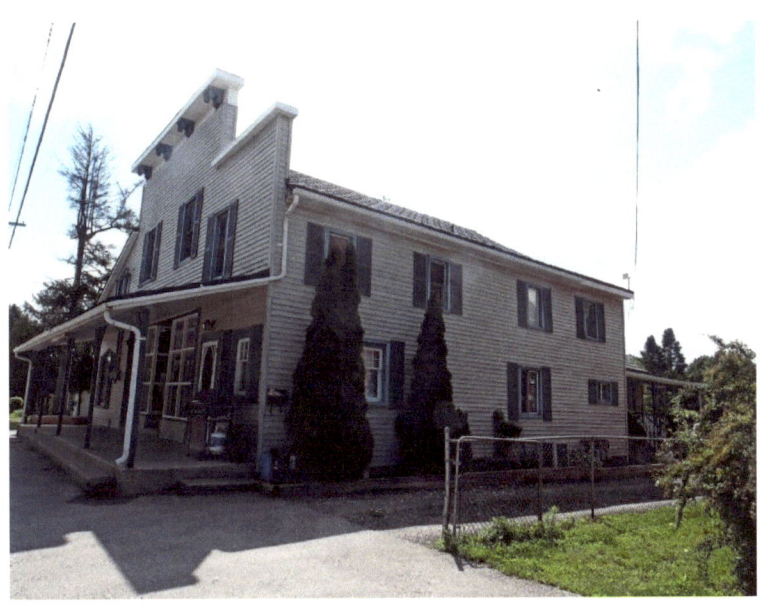

Vernacular

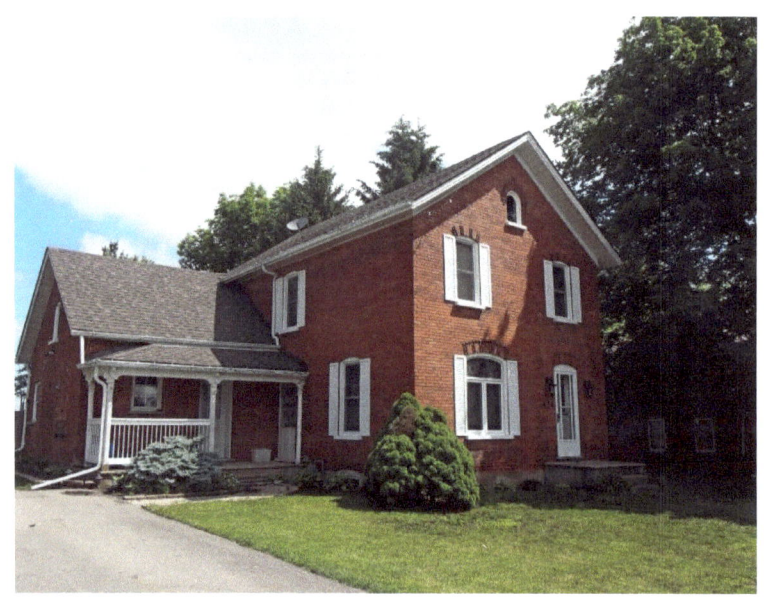

Architectural Terms

Banding: Different materials, colours or textures used in horizontal bands along a wall. Example: Springford Methodist Church, Pg. 60	
Bay Window: A window that projects out from a wall, in a semicircular, rectangular, or polygonal design. Used frequently in Gothic and Victorian designs. Example: Delhi, Page 27	
Belvedere: (from the Italian "beautiful view") an architectural feature on a roof, in a garden or on a terrace that gives a beautiful view. Example: Normandale, Page 40	
Brackets: a decorative or weight-bearing structural element which forms a right angle with one side against a wall and the other under a projecting surface such as an eave or roof. Example: Lynnville, Page 51	
Cobblestone architecture: Refers to the use of cobblestones embedded in mortar as a method for erecting walls on houses and commercial buildings. Example: Wyndham Centre, Page 46	
Cornice: originally the wooden overhang of the roof. With the use of stone, brick, iron and steel, the cornice is any projecting shelf at the top of a ceiling or roof. They can be very decorative. Example: Delhi, Page 25	
Cornice Return: decorative element on the end of a gable. Example: Normandale Union Hotel, Page 36	

Cupola: A domed or curved roof rising from a building as a decorative element. Example: Springford Methodist Church, Pg. 60	
Dentil Moulding: an even series of rectangles used as ornamental decoration in cornices. Example:	
Polychromatic brickwork: the use of more than two colours of brick, tile or slate to decorate a façade. Dichromatic is the use of two colours. Example:	
Dormer: (French for "sleep") a gable end window that pierces through the plane of a sloping roof surface to create usable space in the top floor or attic of a building by adding headroom. Example: Murphy Funeral Home, Delhi, Pg.12	
Entrance: The entrance encompasses the doorway and the inner vestibule or, in residential architecture, the covered porch. Example: Lynnville, Page 52	
Fretwork: interlaced decorative design resembling a bracket Example: Delhi, Page 24	

Gable: the triangular portion of a wall between the edges of a sloping roof. Example: Lynnville, Page 51	
Hipped Roof: a roof where all sides slope downwards to the walls with no gables. Example: Delhi, Page 13	
Iron Cresting: A decorative ornament along the top of a roof. Iron cresting was popular in the Baroque era and also in Italianate, Victorian, Second Empire and Queen Anne styles of architecture. Example: Lynnville, Page 51	
Keystones and Voussoirs: a voussoir is a wedge-shaped element used in building an arch. A keystone is the central stone that locks all the stones into position, allowing the arch to bear weight. A keystone is often enlarged and embellished. Example: Lynnville, Page 51	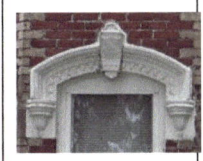
Lancet Window: a tall, narrow window with a pointed arch at its top. Example: St. Casimir's Lithuanian Roman Catholic Church, Page 16	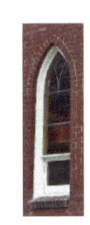
Palladian Window: a large window that is divided into three sections with the centre section larger than the two side sections and usually arched. Example: Delhi, Page 8	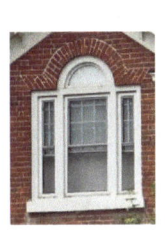

Pediment: a triangular section above the horizontal structure (entablature), typically supported by columns. The inside of the triangle is called the tympanum. Example: Concession 4	
Quoin: masonry blocks at the corner of a wall, often a decorative feature, usually larger or of a different colour than the rest of the wall. Example: LaSalette, Page 44	
Sidelight: a window, usually with a vertical emphasis, that flanks a door, and is often used to emphasize the importance of a primary entrance. **Transom Window:** the light above the doorway, also called a fanlight. Example: Lynnville, Page 51	
Turret: a small tower that projects from the wall of a building. Example: Normandale, Page 38	
Verge board and Finial: also called bargeboards – hang from the projecting end of a roof and are often elaborately carved and ornamented. **Finial:** ornament added to the top of a gable, pinnacle, canopy or spire – a Gothic element. Example: Lynnville, Page 50	
Window Hood: A **hood** is the piece found above window openings, usually of an ornate design, and covers the top third of the opening. Hoods are commonly placed above arched or curved openings on both windows and doors. Example: Lynnville, Page 53	

Building Styles

Cape Dutch architecture is a traditional Afrikaner architectural style found mostly in the Western Cape of South Africa. The initial settlers of the Cape were primarily Dutch. When the Dutch came to Ontario, they brought with them building concepts from their own native lands. Architecture from the 18th and early 19th centuries in Ontario includes a wide assortment of detailing and ornament all applied to a basic building design centred around the fireplace and the source of water. Example: LaSalette, Page 44	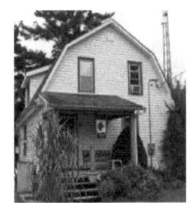
Classical Greek - For the three centuries after the sixth century B.C., the Greeks created monumental buildings with columns, pediments, entablatures, capitals, and bases. Example: Delhi, Page 9	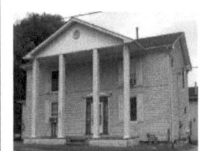
Edwardian, 1900-1930 – This style bridges the ornate and elaborate styles of the Victorian era and the simplified styles of the 20th century. Balanced facades, simple roof lines, dormer windows, large front porches, and smooth brick surfaces are its characteristics. Example: Delhi, Page 26	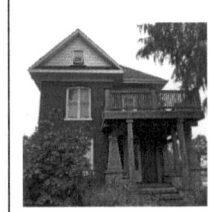
Georgian, before 1860 – This style began with the British King Georges in the 18th century. These buildings have balanced facades around a central door, medium-pitched gable roofs, and small paned windows. Example: Simcoe, Page 57	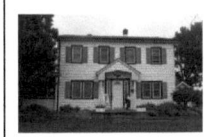

Gothic Revival, 1830-1890 – These decorative buildings have sharply-pitched gables with highly detailed verge boards, pointed-arch window openings, and dichromatic brickwork. It is a common style in Ontario. Example: Delhi, Page 23	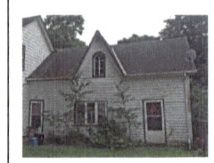
Italianate, 1850-1900 – It has wide-bracketed eaves, belvederes, wrap-around verandahs. Example: Delhi, Page 13	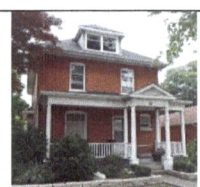
Romanesque Revival, 1880-1910 – This style hearkens back to medieval architecture of the 11th and 12th centuries with a heavy appearance, blocky towers and rounded arches. Example: Curries, Page 58	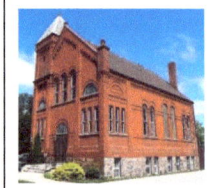
Tudor Revival – exposed timbers with stucco infill, multi-paned windows. Example: Delhi District German Home, Pg. 9	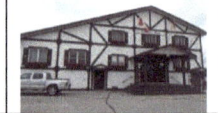
Vernacular/Traditional Mode 1638 - 1950 Influenced but not defined by a particular style, vernacular buildings are made from easily available materials and exhibit local design characteristics. Example: Delhi, Page 12	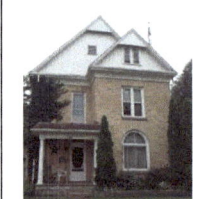
Victorian - In Ontario, a Victorian style building can be seen as any building built between 1840 and 1900 that doesn't fit into any of the other categories. It encompasses a large group of buildings constructed in brick, stone, and timber, using an eclectic mixture of Classical and Gothic motifs. Example: Lynnville, Page 51	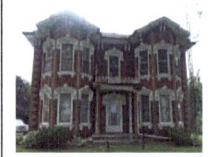

www.ingramcontent.com/pod-product-compliance
Lightning Source LLC
Chambersburg PA
CBHW040811200526
45159CB00022B/248